THE URBAN SKETCHING HANDBOOK

TECHNIQUES FOR BEGINNERS

T0054591

Quarto.com

© 2021 Quarto Publishing Group USA Inc.
Text © 2021 Suhita Shirodkar
Images © 2020 Suhita Shirodkar and as indicated

First Published in 2021 by Quarry Books, an imprint of The Quarto Group,
100 Cummings Center, Suite 265-D, Beverly, MA 01915, USA.
T (978) 282-9590 F (978) 283-2742

Quarry Books titles are also available at discount for retail, wholesale, promotional, and bulk purchase. For details, contact the Special Sales Manager by email at specialsales@quarto.com or by mail at The Quarto Group, Attn: Special Sales Manager, 100 Cummings Center, Suite 265-D, Beverly, MA 01915, USA.

10 9 8 7 6 5 4 3

ISBN: 978-1-63159-929-3

Digital edition published in 2021
eISBN: 978-1-63159-930-9

Library of Congress Cataloging-in-Publication Data is available

Design: www.studioink.co.uk
Illustration: Suhita Shirodkar and as indicated

Printed in China

THE URBAN SKETCHING HANDBOOK

TECHNIQUES FOR BEGINNERS
How to Build a Practice for Sketching on Location

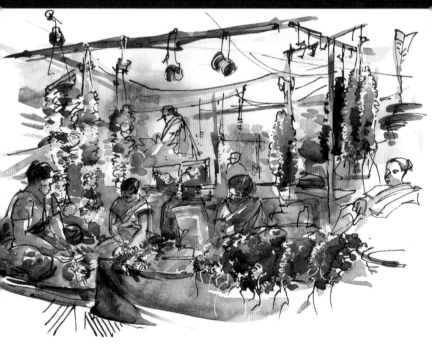

SUHITA SHIRODKAR

About This Series

The Urban Sketching Handbook series takes you to places around the globe through the eyes and art of urban sketchers. Each book offers a bounty of lessons, tips, and techniques for sketching on location for anyone venturing to pick up a pencil and capture their world.

Architecture and Cityscapes by Gabriel Campanario
People and Motion by Gabriel Campanario
Reportage and Documentary Drawing by Veronica Lawlor
Understanding Perspective by Stephanie Bower
The Urban Sketching Art Pack by Gabriel Campanario
Working with Color by Shari Blaukopf
101 Sketching Tips by Stephanie Bower
Drawing with a Tablet by Uma Kelkar
Techniques for Beginners by Suhita Shirodkar
Drawing Expressive People by Roísín Curé
The Complete Urban Sketching Companion by Gabriel Campanario,
 Stephanie Bower, and Shari Blaukopf

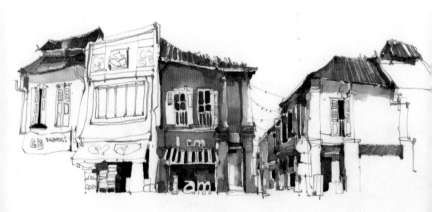

PAUL WANG
Shophouses at Haji Lane,
Singapore
14¾" x 7¾" | 40 x 20 cm;
pencil and watercolor

CONTENTS

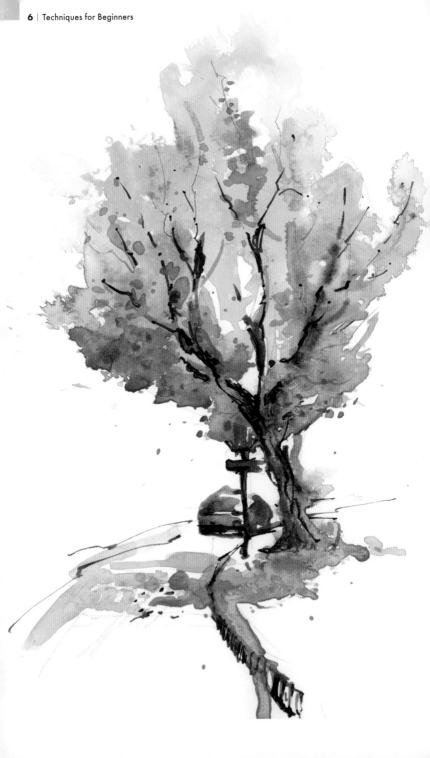

INTRODUCTION

WHAT IS URBAN SKETCHING?

Urban sketching is drawing on location from direct observation. Most urban sketchers work in sketchbooks. These books become stories told over time. They hold memories and meaning, a visual record of sketchers' lives and the world around them.

Sounds complicated? It isn't! You're an urban sketcher if you record what you see: simple objects from your everyday life, landscapes or cityscapes, people in cafés and on the streets. Your sketches can be simple pencil or pen drawings or they might include color. They could be quick little sketches with notes. They're all urban sketches.

WHO IS THIS BOOK FOR?

Maybe you're just starting out on your sketching adventure, or you want to get back to the basics of observational drawing. Perhaps you're looking for solutions to particular challenges that come up with drawing on location. You've drawn architecture forever, but drawing people intimidates you. Or you'll happily draw people and faces, but the word *perspective* might sound scary.

If any of these sounds like you, this book is for you.

Because aren't we all beginners in some way? Beginning something new, beginning to see better, beginning a new sketchbook, a new sketch . . .

⟳ Recording the seasons where I live. I drive past this ginkgo tree almost every day but come fall, its golden yellow foliage begs for a sketch. A red stop sign and a car parked under the tree complete the picture. Everyday sights become special when you record them in your sketchbook.

SUHITA SHIRODKAR
Ginkgo in the Fall
8" x 11" | 20.3 x 27.9 cm;
ink and watercolor

There is no right or wrong way to draw. Styles may vary, what catches your eye may vary, but every urban sketcher shares that aim to capture the world around them in their sketches.

◡ Ketta Linhares

Brescia, Italy

20½" x 7¾" | 52.5 x 20 cm; ink and watercolor

◡ Carlos Almeida

Pier Six Concert Pavilion, Baltimore

5½" x 8" | 13.9 x 21.6 cm; pen and ink

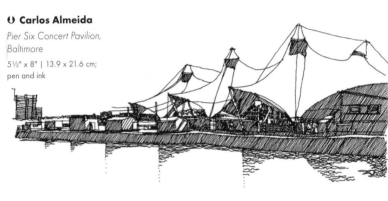

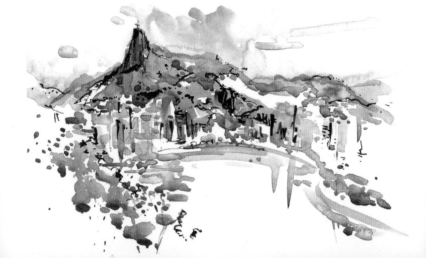

USING THIS BOOK

The Urban Sketching Handbook: Techniques for Beginners is written with a beginning sketcher in mind. It is not only about the craft but also about the practice of urban sketching and about finding ways to integrate it into your life. It addresses common stumbling blocks, like that big blank sketchbook page that's staring back at you or a fear of people watching you while you draw. It offers ideas and advice as well as examples to teach and inspire you.

In writing it, I surveyed beginning sketchers from different parts of the world with the express purpose of finding out what they wanted in a book. I also asked more seasoned sketchers, including the contributors to this book, for tips and advice they would give a beginner or things they wish they had known when they started out.

Where do you start and what do you sketch? You can start anywhere and you can sketch just about anything in the world around you, near or far. Explore your home, your neighborhood, your city, or far-flung places in the pages of your sketchbook.

Each chapter begins with a "Start Here" exercise designed to help ease you into drawing from direct observation. Start where you're comfortable and draw what captures your attention in your world.

The advice and learning techniques in this book are multifaceted and might sometimes seem contradictory. Each of us learns so differently that no single point of view is going to fit us all. If there is anything in this book that sounds like a *must* do, put that down to awkward writing. There is no single correct way to learn anything. Experiment with the ideas in this book, play with the concepts, adapt them, and make them your own.

Sketching is an adventure you embark upon, an unending path. It opens doors to seeing and experiencing in new ways. Finding the time to sketch regularly and staying in learning mode are the two biggest gifts you can give yourself. Enjoy the adventure.

C Suhita Shirodkar
A View of Rio
9" x 12" | 22.9 x 30.5 cm;
ink and watercolor

◑ Every once in a while, I sort through my sketch kit and pare it down to keep it lightweight and simple.

SUHITA SHIRODKAR
Sorting through Supplies
8" x 11" | 20.3 x 27.9 cm;
ink and watercolor

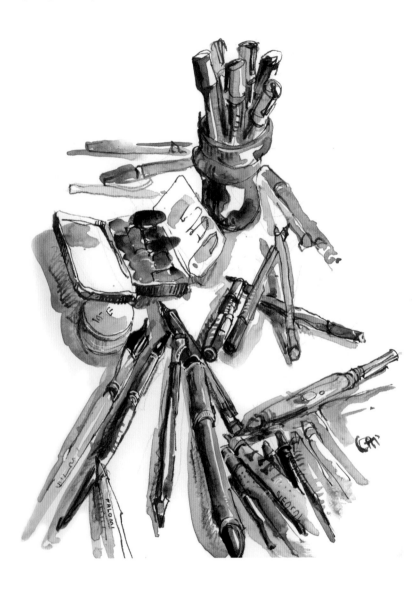

KEY I
STARTING OUT

Pens, pencils, paints, sketchbooks, and a zillion other products. Who doesn't love playing with them all? But the choices can get overwhelming. And too large a kit actually makes urban sketching a more complicated endeavor than it should be.

If you think about it, you really *need* only two things to sketch: a surface to draw on and a tool to make marks with.

Keep it simple and focus on learning to see.

⊃ This is Gabriel Campanario's go-to kit: a ballpoint pen and a small sketchbook. Especially if you're a beginning sketcher, Gabriel strongly recommends *not* rushing into color but starting instead with a ballpoint pen or a pencil.

GABRIEL CAMPANARIO
Olive Tree and Wheelbarrow

7" x 5½" | 17.8 x 13.9 cm; ballpoint pen

TOOLS OF THE TRADE

At the core of all sketching kits, no matter how simple or complex, are three things: line-making tools, shape-making tools, and a surface to draw on. Everything else is an accessory.

The simpler you keep it, the more you will get out of your sketch kit. The best sketch kits have all the tools you want but are compact enough to carry with you almost anywhere.

Let's build a sketch kit step by step. You can also use this method to pare down and simplify your sketch kit by dividing up your supplies by category and seeing what you can live without.

Building a Sketch Kit

1. What Will You Sketch On?

• **A sketchbook.** Keep it small and simple. If you'll use only dry media, choose one with thinner paper. Not sure what media you will use? A mixed-media sketchbook can handle lots of different media, wet or dry.

OR

• If you plan on sketching digitally, you'll be using **a tablet and an app to sketch in.** (If you enjoy sketching digitally, you might like *The Urban Sketching Handbook: Drawing with a Tablet* by Uma Kelkar.)

2. Next, You Need Something to Draw With

• **A pencil** is very forgiving because it erases easily. Graphite pencils vary from harder pencils, which make lighter marks, to softer ones, which make darker, smudgier marks. Find a couple you like the feel of and add them to your kit.

Harder pencil Softer pencil

• **Pens** make a variety of marks and come in many ink colors. The ink in your pen could be water soluble or water resistant. To find out which it is, make a mark on your paper and let the mark dry for a few minutes. Then run a brush with clean water over it. Water-resistant ink will smear very little or not at all, while water-soluble ink will smear. Water-resistant pens make it easy to color in your sketch with watercolor without smearing the line, but water-soluble pens create an interesting effect too. A couple of different pens are a good addition to your kit.

Water-soluble ink Water-resistant ink

• **A white pen** in your kit means you can have a great way to add highlights to your sketches.

3. Now Let's Add Some Shape-Making Tools

If you'd like to avoid carrying water media, you might consider colored pencils, broad-tipped markers, or crayons for your kit.

Some colored pencils are water-soluble, which is a great in-between choice: they're an easy, no-spill medium to work with on location and you can get watercolor-like effects with them by adding water later.

Watercolor is a favorite medium among urban sketchers. It is simple to carry in a compact kit, cleans up easily, and can paint in big shapes quickly. You can buy a small watercolor kit that is prefilled or an empty palette that you can fill with colors you choose.

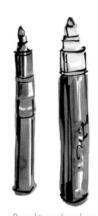

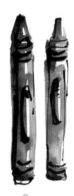

Broad-tipped markers

Crayons

Colored pencils

Marks made with water-soluble colored pencils

Watercolor kit

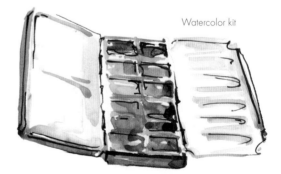

4. A Few Additional Accessories to Help Finish Up the Kit

- An eraser
- A water brush or a travel brush and a small
 water container (if you are using wet media)
- And finally, a bag or pouch to hold it all.

Eraser

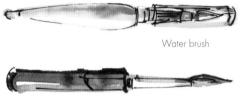

Water brush

Travel brush

Small water container

And your sketch kit is ready to go anywhere you want to sketch.

Photo courtesy of
Roma Bhansali

Setting Up a Watercolor Palette

Unlike studio painting, compact and light palettes are the key to success for an urban sketcher. Carrying fewer colors means your sketches will look more harmonious and you have a lighter palette. And it can't be stressed enough: the more portable your kit, the more likely you are to sketch.

In setting up a watercolor kit for urban sketching, here are some guiding principles:

- Keep it light and compact.
- First choose primary colors (reds, yellows, and blues). Your colors need to work hard for you. They must mix to create a wide range of colors.
- Next, add "convenience" colors: colors that you use often and want quick, premixed versions of, like greens, browns, and neutrals.
- Buy artist-grade watercolors if you can afford them. They make it easier to get vibrant color in your work. If you can't afford them, don't let that stop you. Learning color mixing and knowing your pigments is still the biggest part of good color in watercolor.

Here's my current urban sketching palette.

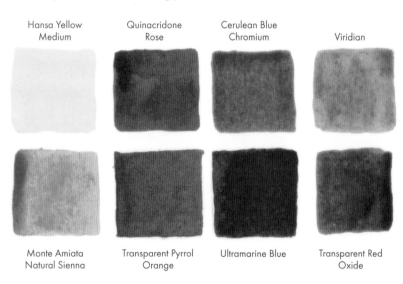

| Hansa Yellow Medium | Quinacridone Rose | Cerulean Blue Chromium | Viridian |
| Monte Amiata Natural Sienna | Transparent Pyrrol Orange | Ultramarine Blue | Transparent Red Oxide |

◖ Two sets of primaries (reds, yellows, and blues) and two convenience colors, a green and a brown.

And my basic urban sketching palette is ready to go. I've also added a few colors I just love and can't mix, but these are added slowly, over time.

↻ When mixed together, the primaries give me a wide range of colors.

Color is a huge and fascinating subject and every artist's palette is different. If you love color and are interested in learning more about it and how it applies to urban sketching, you might be interested in *The Urban Sketching Handbook: Working with Color* by Shari Blaukopf.

↻ And with the green and brown in my palette, I can make lots of shades of green and neutrals by mixing just two colors.

↻ Here's a palette Jane Blundell put together specifically for urban sketching. It starts with primaries and goes from there. Each color in the palette earns a place for a specific reason. Jane says, "This palette has two yellows and two blues. The red is quinacridone rose—a primary red that can be used to mix a range of colors from orange through to purple. The perylene green is a great shadow color in urban foliage, but will mix wonderful greens with any of the yellows. There is a yellow earth, an orange earth, a red earth, and a cool dark earth, as well as the dark and light. The buff titanium and goethite, along with the other granulating earth pigments, create the textures of marble, brick, tile, stone, concrete, and so on."

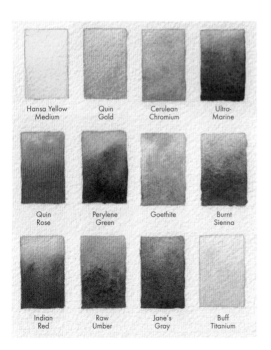

Hansa Yellow Medium

Quin Gold

Cerulean Chromium

Ultra-Marine

Quin Rose

Perylene Green

Goethite

Burnt Sienna

Indian Red

Raw Umber

Jane's Gray

Buff Titanium

JANE BLUNDELL
Urban sketching palette for beginners
2" x 12" | 5 x 30.5 cm; watercolor

Small Kits Tailored to Your Needs

It's often assumed that the more supplies you have, the better the art you will make. Nothing could be further from the truth.

Instead of carrying around an ever-burgeoning sketch kit, try breaking your kit up into smaller kits for specific purposes. The smaller your kit, the more places it can go and the more you will sketch. When you are headed somewhere and your sketch kit seems too big to take along, think about taking a small subset of your supplies and a smaller book.

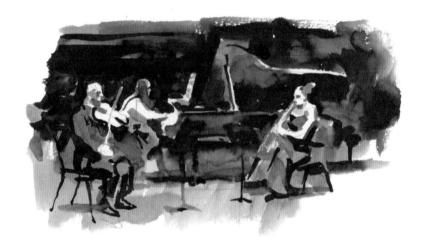

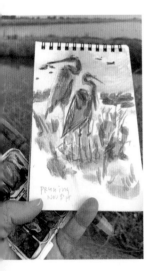

♻ Nina Khashchina's smallest kit fits into her running belt and goes with her on her morning run.

Nina's sketch kit: a small pad of paper, a water brush, and a miniature palette.

NINA KHASHCHINA
Blue Herons
2½" x 1½" | 6.4 x 3.8 cm; watercolor

🎧 James Gurney sketched this at a concert. He says a simple kit and a silent technique are crucial in concert settings.

James's sketch kit: a small sketchbook and two water brushes, one filled with water, the other with black water-soluble ink.

JAMES GURNEY
Chamber Group
5" x 8" | 12.7 x 20.3 cm; water-soluble ink

SHARI BLAUKOPF
Rijksmuseum
8" x 16" | 20.3 x 40.6 cm;
brush pen and watercolor

When Shari Blaukopf visits a museum (where wet media may not be permitted), she draws in pencil or black line, adding color later. She drew this at the Rijksmuseum in Amsterdam with just a brush pen and added color from photo references on her long flight home. **Shari's sketch kit:** sketchbook, pen, and ink.

Brenda Swenson often tucks a small sketchbook and a few pens in her pocket on her morning walk. This little home with the trees framing it caught her attention. She sat on the curb and sketched it using a minimal sketch kit.

Brenda's sketch kit: small sketchbook and brush pens in three shades of gray.

BRENDA SWENSON
Oxley Street
8" x 16" | 20.3 x 40.6 cm; Pitt pens

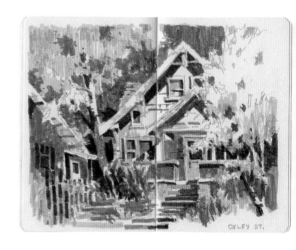

THE BLANK PAGE

Do you fear that empty, pristine page? You're not alone.

Here are some ways in which sketchers get past the hurdle of that first blank page in their sketchbooks.

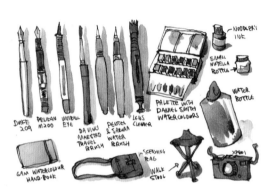

↻ Teoh Yi Chie draws a packing list when going on a vacation. It's a stress-free way to fill the first page of his sketchbook, and it's helpful to refer to it when packing for future trips. He says drawing familiar objects without worrying about composition makes this first page feel less intimidating.

TEOH YI CHIE
Packing list
5.8" x 8.3" | 14.8 x 21 cm;
watercolor, pen and ink

⤳ Ed Mostly precolors pages in his sketchbook. Precoloring can make a page feel less intimidating and pristine. His first color wash is often added at home.

ED MOSTLY
Kingsmead Square, October
7" x 11" | 17.8 x 27.9 cm;
ink, pencil, gouache

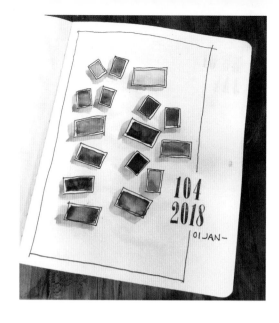

◖ Since 2009 Liz Steel has started all her sketchbooks with a sketch of her current palette. Not only does it solve the problem of what to do on the first page, but it is also a record of the colors used in that sketchbook. Here she keeps her first page simple and whimsical.

LIZ STEEL
Current color palette
8" x 10" | 20.3 x 25.4 cm; watercolor, pen and ink, stamp watercolor

◖ Gay Kraeger's first page is her contact page, always a sensible choice. Sometimes Gay might add a sketch to the page over time, with no first-page pressure.

GAY KRAEGER
First page, Journal No. 52
16" x 10" | 40.6 x 25.4 cm; watercolor, pen and ink

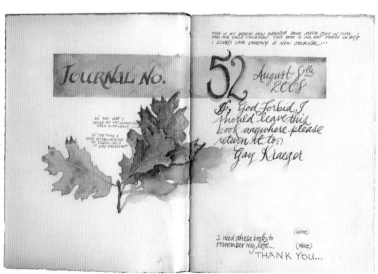

SKETCHING ON LOCATION

Urban sketching has its fair share of challenges: drawing outside with the weather to contend with, with people watching you, and with so much to see you don't know where to start. These are just a few of the challenges. No matter how often you are reassured that practice will make it easier, those first sessions don't get any easier, do they?

If starting outside is too big a first step, start at home. Urban sketching is drawing the world around you from direct observation, and your world starts right where you are. Starting at home, gradually expand that world to encompass the view from a window, then move to sketching from indoor locations near you: your local coffee shop or a museum nearby, for example. If standing on the street is intimidating, sketch from your car. Each little step will build the confidence and skills you need to try that next step, but it never needs to be one big, unnerving move. You are on location wherever you are!

↻ A cold and snowy winter necessitates drawing indoors. Marcia Milner-Brage sketches the view through her bedroom window.

MARCIA MILNER-BRAGE
Silver Maple Winter
12" x 18" | 30.5 x 45.7 cm; water-soluble wax pastels

↻ Is standing on the street and sketching too intimidating? I parked my car and sketched the house across the street. Sketching from the car also keeps you out of the sun, rain, and cold, and extends your outdoor sketching season.

SUHITA SHIRODKAR
Dilapidated but Standing
12" x 9" | 30.5 x 22.9 cm; watercolor, pen and ink

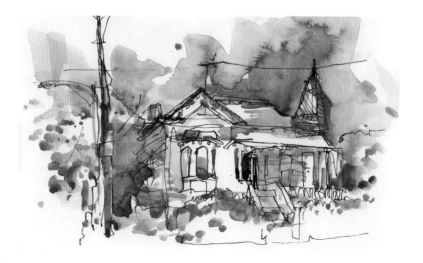

FINDING TIME TO SKETCH

Do you find yourself saying, "I wish I could do this, but I don't have the time"? One of the best things about urban sketching is it's a practice you can start with very little time. Here are some ways in which you can help yourself find time.

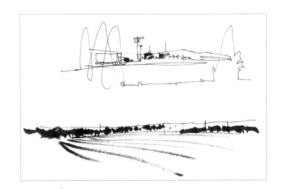

⮑ **Get creative about where you sketch.** Uma Kelkar sketched these pieces in seconds on a long car ride, looking only up at the changing landscape before her and not at her paper. The process builds hand-eye coordination. (Plus, looking up, not down, prevents car sickness!)

UMA KELKAR
Series of sketches from a moving car

Each approx. 1½" x 2½" | 3.8 x 6.4 cm; ballpoint pen and brush pen

⮑ **Start small.** If you can find a few minutes a day, you have a daily sketch practice. Use a small sketchpad and simple tools. Elizabeth Alley draws everyday things. She believes anything becomes special when you draw it.

ELIZABETH ALLEY
Laundry Room and Bedside Table

Each approx. 4" x 4" | 10.2 x 10.2 cm; pen and ink, diluted Sumi ink

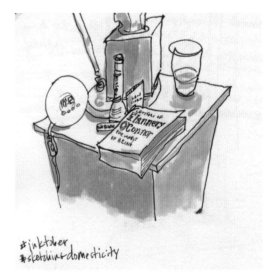

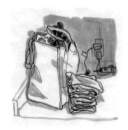

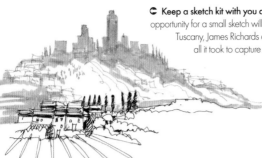

↻ **Keep a sketch kit with you at all times.** You never know when the opportunity for a small sketch will arrive. En route to San Gimignano in Tuscany, James Richards came across this scene. Five minutes is all it took to capture this memory of it forever.

JAMES RICHARDS
San Gimignano Distant View
7" x 11" | 17.8 x 27.9 cm; various black and gray pens

↻ **Make a list.** The less time you have every day, the less time you want to spend thinking of *what* to draw. Keep a list of things you want to sketch in the back of your book. I keep a list of vintage signs in San Jose that I'd like to sketch. Over the years, I've sketched many on my list, but I still have a few left to check off.

SUHITA SHIRODKAR
Vintage Signs of San Jose
7" x 11" | 17.8 x 27.9 cm; various black and gray pens

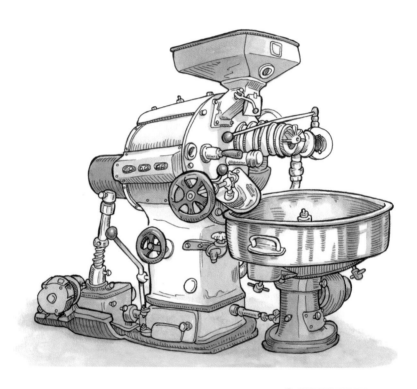

⋂ STEVEN REDDY

Cafe Umbria Grinder

8" x 9" | 20.3 x 22.9 cm;
pen and ink

KEY II
WHAT TO SKETCH: OBJECTS

The objects you interact with every day, big or small, might seem mundane to you at first. But take a closer look at them: Do they tell a story? Are they interesting to sketch? Are they particular to a place? Do they hold a special meaning for you? Any of these reasons makes them worth sketching.

Add a little bit of context to the objects you draw, tell a story in words to go with your sketch, and you have an urban sketch.

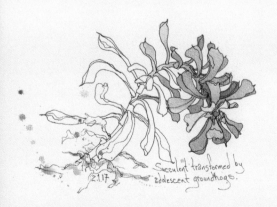

◖ This oddly shaped succulent triggered Chris Carter's memories of a sunny morning when she discovered groundhogs enjoying her succulent as breakfast. The succulent responded by sending out a new shoot, sketched here.

CHRIS CARTER
Succulent Transformed by Adolescent Groundhogs
7" x 11" | 17.8 x 27.9 cm; watercolor, pen and ink

SEEING CONTOURS

Look around your home. Do you see little "still life" arrangements? Not arranged specifically to be drawn, but arranged by the everyday routines of your life? Each of them is an urban sketch waiting to be recorded. The dishes in your kitchen sink, the plants on your windowsill, they're all little stories from your everyday life waiting to be sketched.

I'm sitting at my kitchen table after my kids have left for school. One kid never remembers to clean up after himself. So I sketch the remains of his breakfast, which includes the book he is reading.

Start Here
You Will Need

• Your sketchbook

• Pen or pencil

◑ Step 1. Pick a spot on an object in the grouping you see to start drawing. Look mostly at the object when drawing. Your gaze should move over the contours of the object at the same pace as your hand moves over the paper, eyes and hand in sync. Record the edges of shapes as you move along. Bumps, dents, and imperfections all add to the beauty of the observation. Your line can be continuous or not. It can be thick, thin, or variable.

SUHITA SHIRODKAR
Remains of Breakfast
9" x 11" | 22.9 x 27.9 cm;
pen and ink

➲ **Step 2.** You can move freely between objects as you draw. Look at relative angles between different edges as you draw them, and observe how interesting the negative spaces are. When a contour line defining an object disappears behind an overlapping object, make sure it continues in a believable spot when it reappears.

Negative Space

Continuing Contour

➲ **Step 3.** Keep going until you have drawn all the objects you want into your sketch.

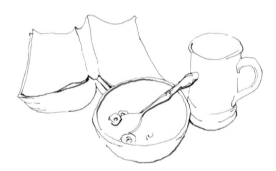

↻ **Step 4.** Now add any last details, but don't let them overshadow the main subject. I added suggestions of texture, shadows, and my view of the kitchen beyond the breakfast table, to give the sketch context and a sense of place.

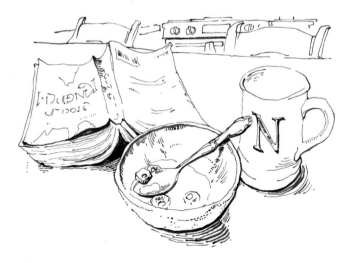

Contour drawing works with subjects big and small, near and far. You can keep your tool kit light and sketch anywhere with this technique. Try going supersimple with just one drawing tool and paper, or try variations on the technique.

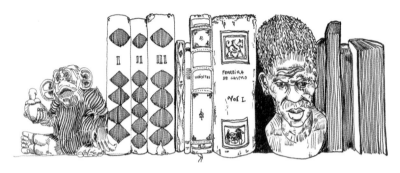

◑ In this drawing made with one pen, Mário Linhares uses line to capture the textures and details in this tableaux.

MÁRIO LINHARES
Book and Curiosities Shelf
7¾" x 15¾" | 20 x 40 cm;
pen and ink

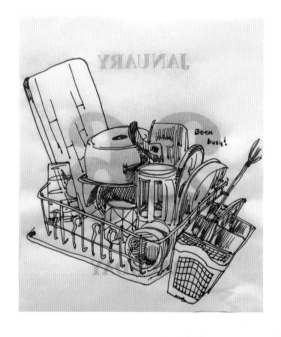

⮌ By capturing ordinary everyday scenes and by working on material like this tearable calendar sheet, Karen Jiyun Sung uses daily sketches to bring focus to her life, her place, and what she sees.

KAREN JIYUN SUNG
Dishes
5" x 8" | 12.7 x 20.3 cm;
pen

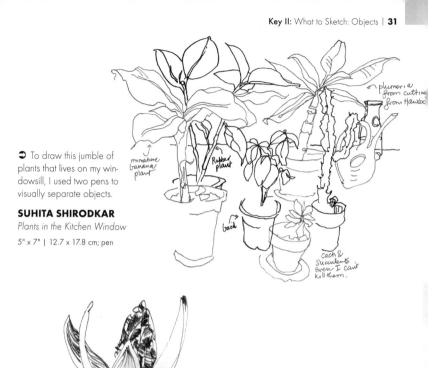

➲ To draw this jumble of plants that lives on my windowsill, I used two pens to visually separate objects.

SUHITA SHIRODKAR
Plants in the Kitchen Window
5" x 7" | 12.7 x 17.8 cm; pen

☛ This sketch of a is one of a series where Nina Khashchina drew the hyacinth bulb every day as it grew. In this piece, she starts with contour drawing and then dips her fingers in ink and water and uses them as tools, smudging and stamping to create different textures and shades.

NINA KHASHCHINA
Hyacinth Day-by-Day
(one of a series)

SIMPLIFYING WITH SHAPE

Sometimes you look at an object and it looks so detailed you don't know where to start drawing it. Seeing it in big shapes helps simplify and unify all the parts of it.

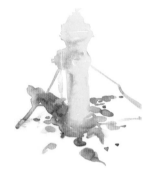

➲ **Step 1.** This fire hydrant has a fair amount of detailing, but under all that is a single big shape. I capture that shape first, looking carefully at its silhouette. Switching colors, but continuing in a single shape, I capture its shadow to help ground it and add a few spots of color for the fall leaves on the pavement. Just shapes—no details yet.

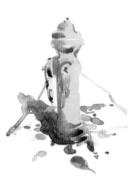

➲ **Step 2.** Observe the smaller shapes created by shadows and rust marks on the hydrant. Look carefully: rarely do you see perfect geometrical shapes you can name. The big yellow shape of the hydrant is cylinder-like, not a perfect cylinder. The smaller shadow shapes on it aren't shapes you can name either.

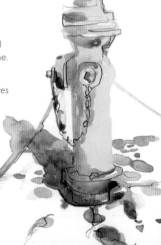

➲ **Step 3.** And to finish, I add just a few details in line.

SUHITA SHIRODKAR
Fire Hydrant and Fall Leaves
9" x 11" | 22.9 x 27.9 cm;
watercolor, pen and ink

Seeing in shapes first can be applied to objects small or large. It comes in handy when your subject might move away quickly. You can capture the big shape first, and then record the details in the time you have left.

SUHITA SHIRODKAR
Tree-Trimming Truck
8" x 10" | 20.3 x 25.4 cm;
watercolor, pen and ink

➲ When I spotted this tree-trimming truck, I quickly recorded a big shape in orange and gray watercolor. In what time I had left, and without waiting for the paint to dry fully, I added detail before it moved away. The suggestions of the road and the tree were added after the truck left.

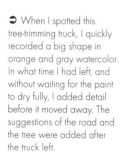

LINE AND SHAPE COME TOGETHER

One of the most common questions about the process of sketching is whether you sketch in the line or shape first. Line and shape are just two ways of translating the world into sketches: one sees edges, the other sees masses. When the two come together and play off each other, they create engaging visuals.

○ Laurie Wigham's sketch of a pile of seaweed she came across at the beach is a dynamic balance of line and shape.

SUHITA SHIRODKAR
Vehicles at History San Jose
12" x 8" | 30.5 x 20.3 cm; watercolor and brush pen

○ In these sketches of vehicles, line and shape come together just enough for the viewer to see the picture, even when parts of it aren't explicitly drawn in.

LAURIE WIGHAM
Seaweed Pile, Asilomar Beach
17" x 6" | 43.2 x 15.2 cm; watercolor

FORM AND SHADOW

Form is a three-dimensional object in space. But paper is a flat, two-dimensional surface. One way to translate our world onto paper is to convincingly convey an illusion of form on a flat page. Understanding what happens when light falls on basic forms helps us understand and deconstruct the more complex forms and lighting that we see in our everyday world.

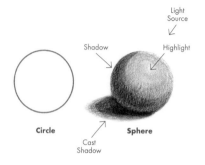

Light Source

Shadow — Highlight

Circle **Sphere**

Cast Shadow

↻ A circle can convincingly look like a sphere if you create an illusion of light and shadow. When light hits a spherical object, the part where it directly hits has a bright highlight. This gradually moves into a midtone and then to the shadow. The shape of the shadow is what molds the circle into a sphere. A second shadow, this one cast by the sphere (and therefore called the cast shadow), is the one that grounds it and puts it in context of its surroundings.

↻ You can see this same phenomenon in this sketch of persimmon. Under all the details are spherical shapes being lit by a strong directional light.

SUHITA SHIRODKAR
Persimmon in My Kitchen
9" x 12" | 22.9 x 30.5 cm;
watercolor

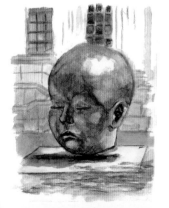

↻ This giant sculpture is of a whole head, features and all. But you can still see the molding of the spherical shape that gives this bronze piece its volume and form.

HOWIE GREEN
Giant Baby Head, Museum of Fine Arts, Boston
5" x 7" | 12.7 x 17.8 cm;
pencil, watercolor pencil,
watercolor

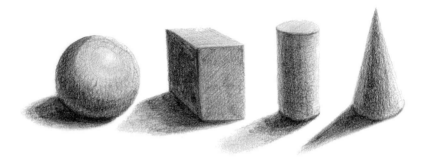

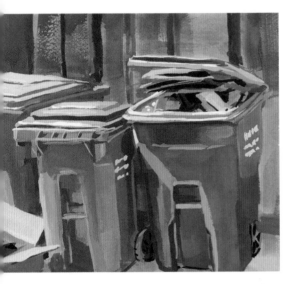

◑ Seeing everyday objects as simple forms will help you decipher how light and shade molds them.

◒ Heather Ihn Martin's composition of bins is a study in light on rectangular boxes. Note the cast shadow of the lid on the bin.

HEATHER IHN MARTIN
Garbage Day
9" x 12" | 22.9 x 30.5 cm;
gouache on watercolor paper

◐ Nina Johansson's sketch of her waffle is a study of light hitting a series of small open-topped boxes, all lined up in a grid.

NINA JOHANSSON
Une Gaufre à Lièg
7¾" x 7" | 20 x 18 cm;
pen and ink, watercolor

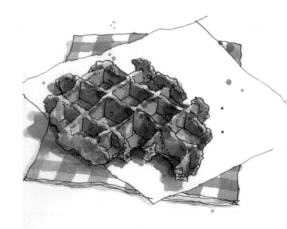

⭢ This complex-looking equipment can all be broken up into basic forms. How many simple forms can you see in it?

VIRGINIA HEIN
Hospital Roof View
5" x 5" | 12.7 x 12.7 cm;
pencil, gouache, watercolor

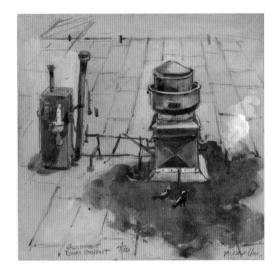

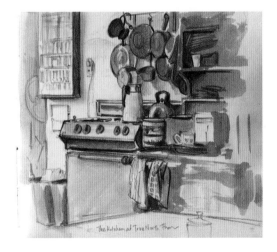

⭠ In James Gurney's sketch, find the main source of light and then think of all the kitchen implements and appliances as simple forms being shaped by that light.

JAMES GURNEY
Kitchen Farm
7" x 8" | 17.8 x 20.3 cm;
pencil and ink washes

ADDING TEXTURE TO FORM

Once you start to see objects as a collection of forms, you can take it a step further and consider material, texture, and pattern.

The material something is made from changes the way it reflects light. Highlights and reflections are sharper and more dramatic on shiny surfaces and more subdued on matte surfaces. Texture and pattern add interest and individuality to objects but are most successfully rendered when they are secondary to form.

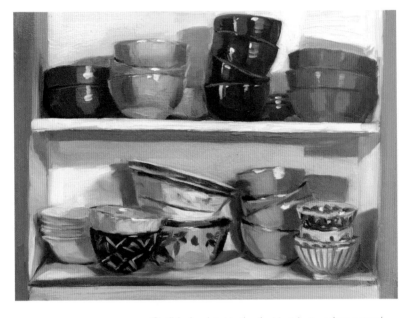

○ All the bowls in Heather Ihn Martin's piece share a roundness of form. It is the more subtle differences that make them an interesting collection: how the light catches on their shiny or matte surfaces and the patterns and colors on them.

HEATHER IHN MARTIN
Mismatched Bowls
9" x 12" | 22.9 x 30.5 cm;
oil on panel

⤷ The forms of this well-loved soft toy are broken up by a fuzzy, soft texture.

SUHITA SHIRODKAR
Woofie Bear

6" x 6" | 15.2 x 15.2 cm;
watercolor, colored pencil

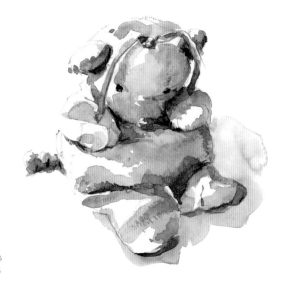

↺ Nina Khashchina overlays gnarled and knobbly textures over the conical shape of these carrots.

NINA KHASHCHINA
Beautiful Carrots That Were Supposed to Be Ugly

5½" x 8½" | 13.9 x 21.6 cm;
watercolor, pen and ink

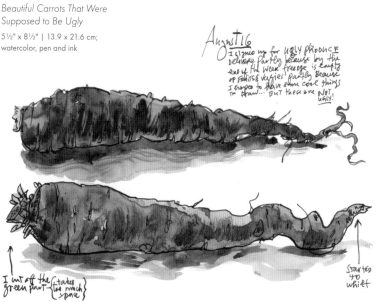

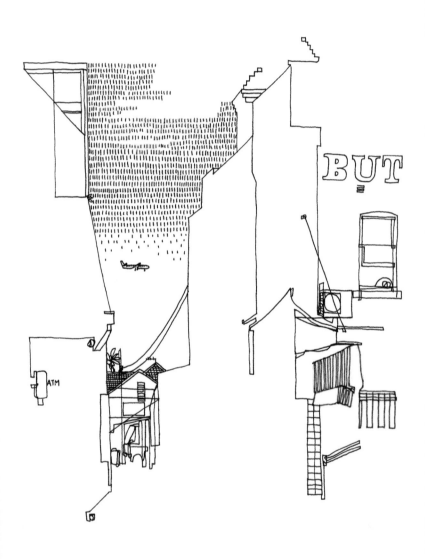

🎧 Richard Briggs is interested in the spaces between buildings. In the narrowest of spaces, he searches out and sketches snippets of life.

RICHARD BRIGGS

But Where Are You Flying to?

8¼" x 11½" | 21 x 29.7 cm; pen

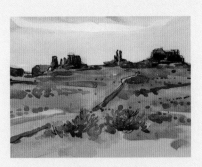

KEY III
WHAT TO SKETCH: PLACES

Landscapes and *cityscapes* are words that make us think of sweeping vistas and detailed scenes. But capturing a sense of place does not always have to be grand. Sometimes the smallest little corner of a scene holds more meaning than the big view.

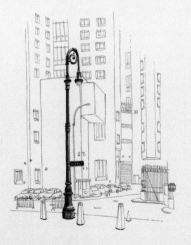

↩ As Fred Lynch traces his family's history, he searches for a sense of place in a world that has changed. Among the tall buildings of Lower Manhattan, an old lamppost calls out to him. It links stories of his ancestors, who lived in the area, to the present.

FRED LYNCH
Pearl Street Lamppost
8" x 10" | 20.3 x 25.4 cm; pen and ink

FRAMING VIEWS

The human eye can see in a visual arc of about 120 degrees, but most of this visual field is in our peripheral vision. At any given point, your in-focus view is limited, preventing visual overwhelm. Framing works similarly: you choose a small part of the view to focus on and leave out the rest. Framing a scene helps keep it simple and lets you choose the story you want to tell.

One way to frame a view is to carry around a small viewfinder. You can make one yourself using a thick acetate sheet or a small piece of acrylic on which you draw a grid with a permanent marker.

<u>Start Here</u>
You Will Need

- A viewfinder
- A dry-erase marker
- A pencil
- Your sketchbook
- A medium to color (if you wish to add color)

↻ Step 1. Move your viewfinder around, looking through it at different parts of the view before you. When you see a framed view that looks interesting, use your dry-erase marker to draw the main contours of the scene directly on the viewfinder.

I tried a few views of Pigeon Point Lighthouse—some vertical, some horizontal, before I found one I liked.

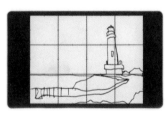

⊃ Step 2. Decide how large you want your sketch to be. With a pencil, draw a grid on your sketchbook page. The grid needs to be the same *proportion* as the viewfinder grid; it does *not* have to be the same size. Here, I drew a grid of 3 x 4 squares in a size larger than the viewfinder. Transferring from one grid to another means looking at relative angles and distances of contour lines in each box. You are now done with your viewfinder.

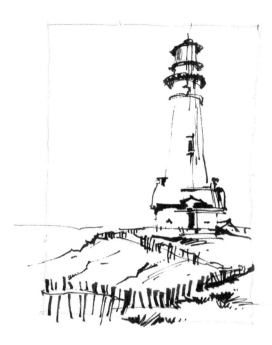

↪ **Step 3.** With a strong compositional foundation for your sketch, switch back to looking at your subject and draw in details from direct observation. I inked in my sketch here, making it easy for me to erase the grid lines before adding color.

↪ If you wish to, you can add color in a medium of your choice.

SUHITA SHIRODKAR
Pigeon Point Lighthouse
4" x 5" | 10.2 x 12.7 cm;
watercolor, pen and ink

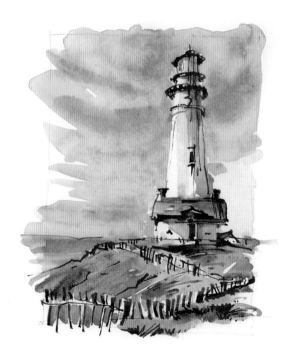

Framed Views

⮑ Shilpa Agashe used a very small (1-inch [2.5-cm] square) viewfinder to zoom into specific details of her living room, making for interesting abstractions.

SHILPA AGASHE
Inside Views
A5 (5¾" x 8¼" | 14.8 x 21 cm); pen, colored pencil

⮑ Cathy McAuliffe drew and painted this spread in little boxes on a train trip. The constantly changing view meant she had to simplify her sketches by just capturing the big shapes and feeling of the landscape.

CATHY MCAULIFFE
Train to Sacramento
3½" x 5½" | 8.9 x 13.9 cm; pencil and watercolor

Windows and doors are viewfinders in our everyday world. They limit and highlight the view we see through them.

↺ Alex Snellgrove contrasts the geometric shape of the window with the organic lines of the rhododendrons outside.

ALEX SNELLGROVE
Kitchen Window, Blackheath
A4 (8¼" x 11½" | 21 x 29.7 cm); acrylic paint, acrylic pen, fineliner, marker

↪ Karen Jiyun Sung sketches a framed view through the breakroom door.

KAREN JIYUN SUNG
Coffee Station
5" x 8" | 12.7 x 20.3 cm; pen

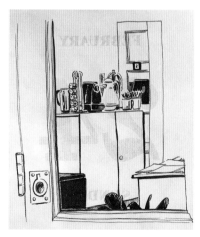

PUZZLING IT TOGETHER

Puzzling together a view is a great way to get past what you *think* you see to what you *actually* see. Look carefully at shapes and paint them in, starting with the shape that stands out the most. Don't name the things you paint; stay focused instead on seeing abstract shapes and putting them together like a jigsaw puzzle. It takes focus, but the results are rewarding.

⊃ **Step 1.** Look at the view and identify a big shape that stands out for you. I am looking at Tower Hall on the campus of San Jose State University. I start my "puzzle" by painting in the shape of the sky.

⊃ **Step 2.** Paint in smaller shapes next, one color at a time. Try keeping the shapes connected when you can. I paint in the terra-cotta shapes and then move to painting all the green shapes.

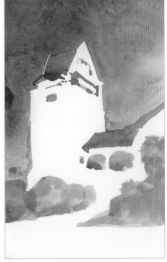

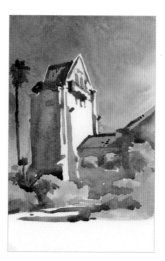

☾ **Step 3.** Paint in the shadow shapes in a single color. The shapes you paint might fit together like a puzzle or they might overlap previously painted shapes. If there will be overlap, make sure the paint underneath is dry before you add more paint. Today the shadows have a purplish hue, so I mix up some color and paint in shadow shapes across everything I see.

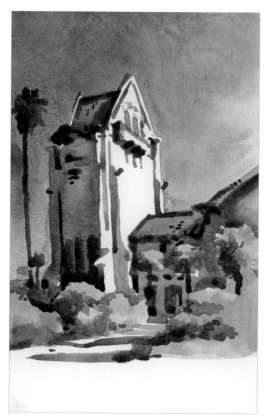

☾ **Step 4.** Add in the darkest shapes and the last details. I add in the details within the shadowed side of the building and some depths to the vegetation around it.

SUHITA SHIRODKAR
Tower Hall, San Jose State University
4" x 5" | 10.2 x 12.7 cm; watercolor

LET'S TALK PERSPECTIVE

If you used a grid to help translate a scene into your sketchbook, or puzzled together a sketch using the method on the previous pages, you're already working with perspective by using acute observation of relative angles and sizes.

Perspective is the art of capturing the illusion of depth and distance on a two-dimensional surface. Understanding the basics of perspective will make it easier to see and translate the world around you into sketches.

The Eyeline

One of the most important things to understand in perspective drawing is the eye-level line (also called the eyeline and sometimes confusingly called the horizon line). The eye-level line is simply the horizontal line in your scene that is perfectly level with your eyes. If you hold a pencil horizontally right in front of your eyes and look past it at your scene, you have found your eye-level line in the view before you.

To start drawing using perspective, you'll need to mark your eyeline on your sketchbook page. Is most of what you are interested in sketching above or below your eyeline?

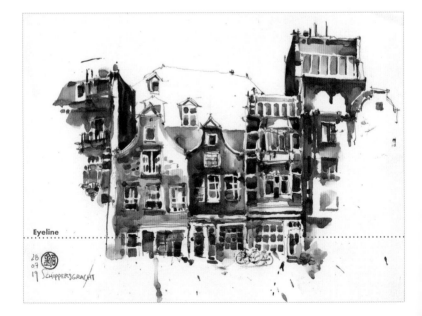

Eyeline

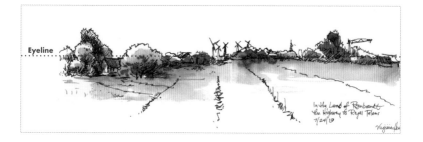

❶ If most of what interests you falls below your eyeline, then mark it high on your sketchbook page.

VIRGINIA HEIN

Highway to Royal Talens

11¾" x 9" | 30 x 23 cm; pen and ink

❷ To capture the view above and below your eyeline, mark the eyeline near the middle of the page.

HUGO BARROS COSTA

Calle Amparo Guillem, Valencia

16½" x 8¼" | 42 x 21 cm; felt-tip pen and watercolor

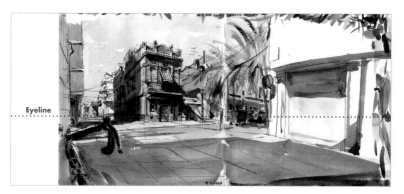

❸ If most of what interests you is above your eyeline (approximated here by the red dotted line) mark the eyeline low on your sketchbook page.

PAUL WANG

Old Dutch Houses at Schippersgracht, Amsterdam

11¾" x 9" | 30 x 23 cm; pencil and watercolor

Thinking in Blocks

To understand simple perspective before you get out and sketch, you can set up a few wooden blocks at home. They can be kids' building blocks or pieces of wood from a hardware store. You can leave them as is or paint on a grid of windows.

↻ For the most common "street view," **DON'T** set them up on your desk with you looking down at them.

↻ Instead, set the blocks up on something that raises them to about how you'd see a tall building if you were standing on the street.

One-Point Perspective

↻ When you're standing in the street and you're looking at the building you want to draw straight on, with its face directly at you, you won't see any of its sides, just a façade, and the face keeps its true shape and proportions with no distortion. You're dealing with *one-point perspective*.

➲ If the building is slightly off to the side (but not by much) and still facing you, you will see a bit of a distorted side. If the face remains undistorted, you're still dealing with one-point perspective.

You can use these images to follow through the next few steps. Better still, set up a block in this position and draw your observations.

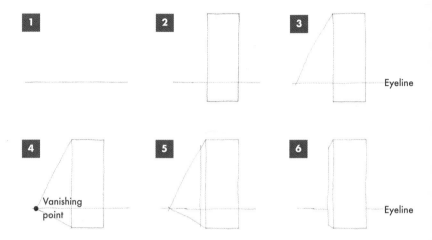

1. First, mark your eyeline. Most of your block is above your eyeline, so mark it low on your page.

2. Draw the undistorted face of the block as a rectangle. Judge its proportion and how much of it is above your eyeline.

3. Look at the distorted side. Hold your pencil up to the top line of that side, judge how steeply it angles down, and replicate it on your page.

4. Do the same with the bottom line, noting how much it angles up. Notice how the top line angles down much more steeply than the bottom line angles up. Also notice how the two angled lines meet at the eyeline. (Close to the eyeline is good enough.)

5. Judge how far back the distorted side of the block goes, and drop a vertical line. Notice how little you see of this side of the block. Your block, in one-point perspective, is now done.

6. Clean up the extra lines if they bother you.

♠ If you wish to add details to the face of your block:

• On the undistorted face, simply draw a grid to line up doors and windows.

• On the distorted face, horizontal lines will converge to the vanishing point. Verticals lines don't distort. Just suggest surface features and don't draw in all the detail.

◐ To focus on the beauty of this façade, Stephanie Bower chooses a simple one-point perspective view. When she sits directly in front of the building, she gets an undistorted view of the façade. She pays special attention to shadows and the overhang of the roof that give this sketch its solidity. A view of the city in the background adds depth.

STEPHANIE BOWER

Noordeinde with Marleen, Holland

5" x 7" | 12.7 x 17.8 cm; pencil and watercolor

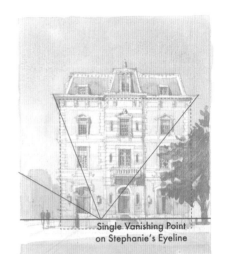

Single Vanishing Point
on Stephanie's Eyeline

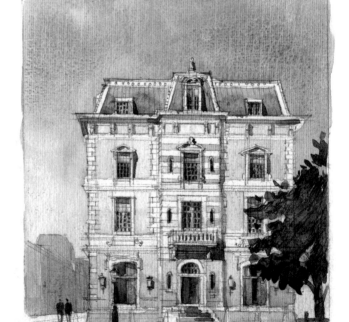

↻ Andy Reddout's classic looking-straight-down-an-alley sketch employs one-point perspective. Where are those undistorted faces of the building, so characteristic of one-point perspective? Imagine the faces of those two buildings in the foreground—they're just cropped out of view in this sketch.

ANDY REDDOUT
Springtime Blood Alley
9" x 12" | 22.9 x 30.5 cm;
watercolor, ink, markers

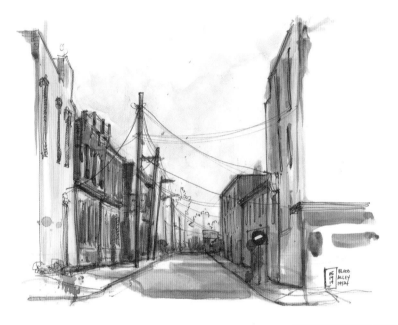

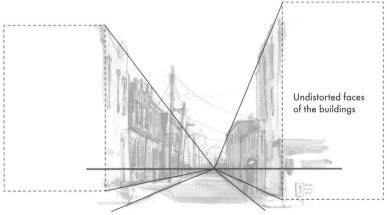

Undistorted faces
of the buildings

Two-Point Perspective

When that block has its *edge* or *corner* facing you, you're dealing with **two-point perspective.**

➲ In **two-point perspective,** both sides of the box will distort, but each to its own vanishing point on your eye-level line. There is no undistorted surface in this view.

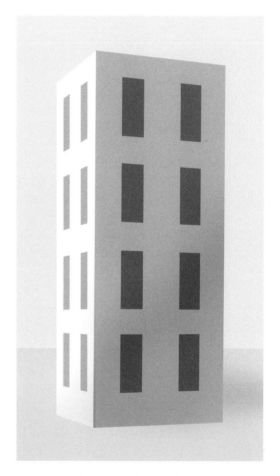

You can use the image above to follow through the next few steps or set up a block like this and draw from it.

1

2

3
——— Eyeline

4
• Vanishing
point

5

6
— Eyeline

1. Start by marking your eyeline on your page.

2. Note that both sides of the block are distorted. Draw the line that represents the corner of the block nearest you, observing how much of it is above your eyeline and how much below.

3. Pick a side. Hold your pencil up to check how steeply the top angles down and replicate it on your page. Then repeat with the line at the bottom, angling up. Do your lines go off the page before reaching the eyeline? That's pretty common in sketching on location. If they're headed toward each other and look like they'd meet at about the level of the eyeline, you're in good shape.

4. Repeat with the other side, observing angles carefully. Again, your vanishing point might be off the page.

5. Judge how far back the sides of the block go and drop a vertical on each side.

6. Clean up the extra lines if you want. You now have a block in two-point perspective.

⊙ To add in details to the face of your block:

Both faces are distorted. The only line you can think of as undistorted is the corner of the block closest to you. Mark an approximation of where the windows would go on that edge.

Use these markings to fan out lines that converge to your two vanishing points. Vertical lines don't distort. The more distorted a surface is, the more you should suggest surface features lightly.

↻ Mark Alan Anderson's sketch demonstrates how two-point perspective can bring dynamism and solidity to a sketch. While the vanishing points are off the page in this sketch, you can see how all of Mark's lines distort in the general direction of where they would lie. Can you see how the porch attached to this building can be thought of as a second block with the same vanishing points as the main building block?

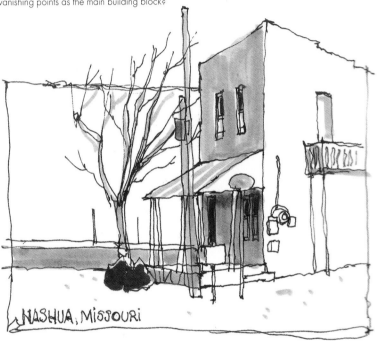

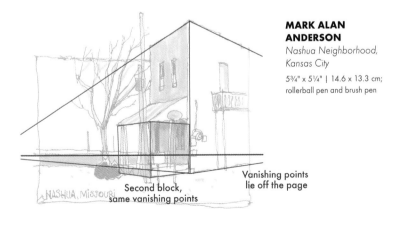

MARK ALAN ANDERSON
Nashua Neighborhood, Kansas City
5¾" x 5¼" | 14.6 x 13.3 cm; rollerball pen and brush pen

Vanishing points lie off the page

Second block, same vanishing points

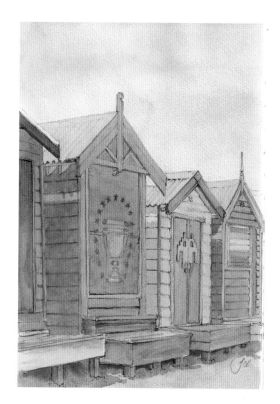

◐ Jane Blundell's sketch of brightly colored bathing boxes uses two-point perspective to build out this seemingly complex siding on the buildings.

JANE BLUNDELL
*Brighton Beach
Bathing Boxes*
10" x 7" | 25.4 x 17.8 cm;
watercolor and ink

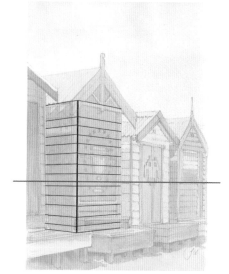

On each structure, siding above the eyeline angles downward

Siding below the eyeline angles upward

Points to Remember

When drawing using perspective on location, understand concepts, but don't feel fettered by them. You don't have to measure things with a ruler and mark eyelines and vanishing points every time you draw. (Unless you like to, then that's okay too!)

☉ All horizontal lines angle towards the eyeline. Things above your eyeline angle down toward it, and things below your eyeline angle up toward it. You don't have to be exact. Paul Heaston intuitively sets up things to follow the general rules of perspective without establishing an eyeline or vanishing points. Here he playfully exaggerates the angles of the verticals of the truck to emphasize the truck's scale and make it look like it towers over him.

PAUL HEASTON
Moving Truck

7" x 5½" | 17.8 x 13.9 cm;
pen on tinted paper

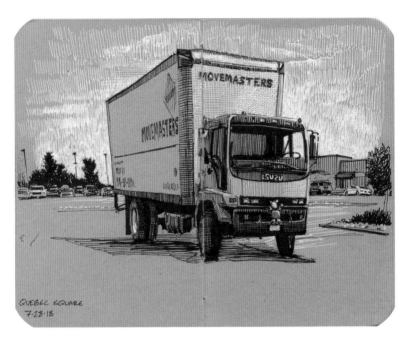

⮎ The angle of a line gets steeper the higher or lower it gets from your eye line. In Simone Ridyard's sketch, the higher the floor on the building, the more steeply the line angles down toward the eyeline.

SIMONE RIDYARD
Whitworth Street, Manchester
5" x 8" | 12.7 x 20.3 cm; watercolor, pen and ink

⮌ Objects appear to get smaller and closer to each other as they move further away. This is true of repeating objects that are equidistant, like the lampposts in Gail Wong's sketch. Estimate how far apart you want to draw the first and second lamppost, and then make sure each subsequent lamppost is drawn at a smaller distance away.

GAIL WONG
Wabash Under the EL
5" x 8½" | 12.7 x 21.6 cm; ink on paper

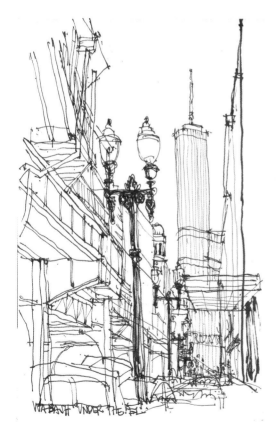

Perspective is a powerful concept you can use in your sketches once you understand it. We've touched on only the basics of it. If it interests you, you might enjoy *The Urban Sketching Handbook: Understanding Perspective* by Stephanie Bower.

CHOOSING YOUR VIEWPOINT

When drawing on location, you can't always choose where to sketch from, but when you can, choose your viewpoint based on what you want your sketch to say.

➲ Ian Fennelly sketches this scene with Big Ben right in front of him, so it is simplified to just its iconic façade. He uses the dramatic angles of the red bridge and the green building to pull you right into his sketch.

IAN FENNELLY
Westminster Bridge
11¾" x 9¾" | 30 x 25 cm;
fineliners and watercolor

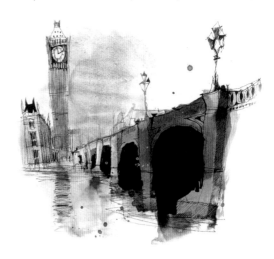

↺ Genine Carvalheira takes simplification a step further and leaves out all hints of dimension to create this stylized view that accentuates the unique façades of these canal houses.

GENINE CARVALHEIRA
Amsterdam Flats
7" x 10" | 17.8 x 25.4 cm;
watercolor and ink

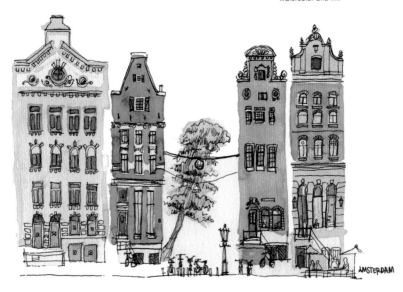

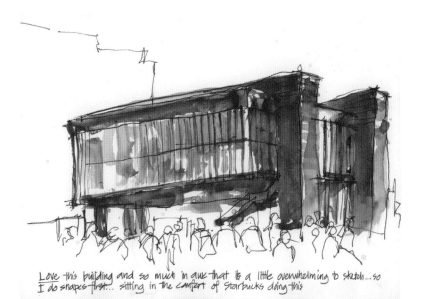

Love this building and so much in awe that it is a little overwhelming to sketch... so I do shapes first... sitting in the comfort of Starbucks doing this

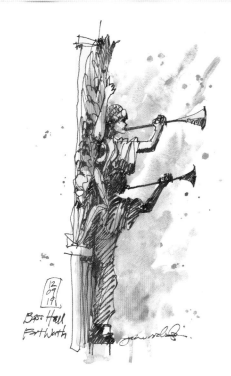

↻ To capture the structure of the iconic MASP building, Liz Steel chooses this two-point perspective view that highlights the structure's solidity and design.

LIZ STEEL
MASP Brazil

8¼" x 8¼" | 21 x 21 cm; watercolor, pen and ink

↻ James Richard's sketch reminds us that no matter what the view before us, we don't have to draw it all. He focuses on just these sculptures on the façade of Bass Hall.

JAMES RICHARDS
Angels at Bass Hall

7" x 11" | 17.8 x 27.9 cm; watercolor, pen and ink

UNDERSTANDING VALUE

Too often, we note the color of something, but not how light or dark it looks. If you started your sketching journey working in color, you might wonder why value is so important. But look at a sketch without color and you'll be surprised by how much you "read" a scene through just light and dark shapes.

◑ *Value* is the lightness or darkness of a color. Value is best understood as a scale, with white on one side, black on the other, and grays in between.

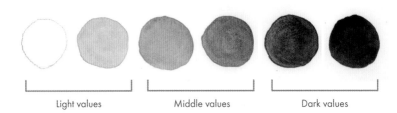

Light values Middle values Dark values

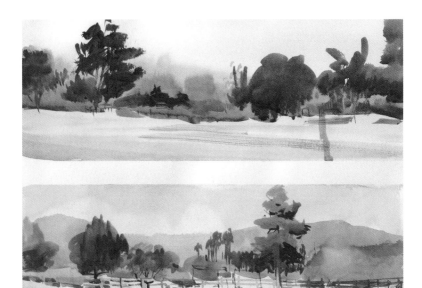

◑ Can you tell what you're looking at in these monochromatic sketches? No color, a minimal amount of texture and detail, just a juxtaposition of darker and lighter shapes next to each other. And yet they're not hard to read, are they?

UMA KELKAR
Woodley Cricket Ground Looking East (top) and West (bottom)

Each approx. 11" x 4" | 27.9 x 10.2 cm; watercolor

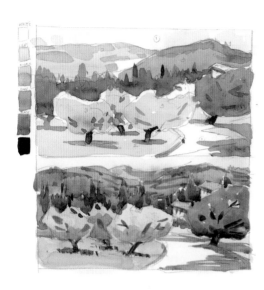

↻ Shari Blaukopf paints this scene twice—first in monochrome, next in color. This is a really good practice that makes you think in values before adding color to the mix.

SHARI BLAUKOPF
Olive Grove

8¼" x 8¼" | 21 x 21 cm; watercolor and pencil

↺ One of the most common reasons a sketch lacks punch is because there are not enough dark values. I did this quick sketch at my street corner and when I came back home, it looked flat. So I added some darker values to it. Especially when working in watercolor, it's important to check values when your sketch dries. Watercolor tends to get lighter when it dries, and your sketch that looked rich and vibrant at first might look insipid when dry.

SUHITA SHIRODKAR
Truck and Mt. Umunhum

4" x 5" | 10.2 x 12.7; watercolor, pen and ink

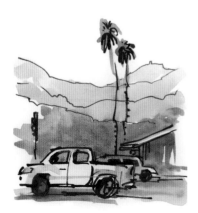
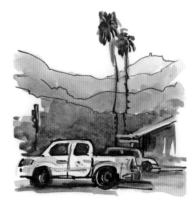

Using Value

⮑ **Value can create focus.** High contrast values placed side by side, where the light awning meets the dark tree, create focus in this sketch.

UMA KELKAR
The Weekend Is Here
5" x 7" | 12.7 x 17.8 cm; water-soluble graphite

↻ **Value can capture atmosphere.** On sunny days, value contrasts are strong and the edges of shapes are sharp. On overcast days, values are closer together and contrasts are lower. If it is foggy, shape edges get very soft. From looking at the these sketches, can you guess at what the day might have been like?

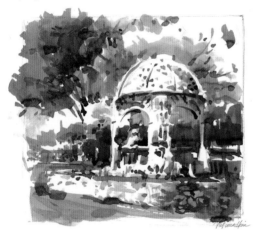

C VIRGINIA HEIN
Gazebo, Descanso Gardens
8" x 8" | 20.3 x 20.3 cm; watercolor

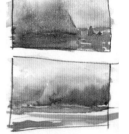

ⴖ TRACEY THOMPSON
Cliffs at Santa Cruz Island
Various sizes; watercolor with ink border

C MARIA CORYELL-MARTIN
Blue Haven
4" x 6½" | 10.2 x 16.5 cm; watercolor

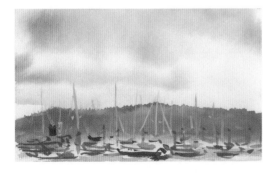

SEEING IN SHAPES

Defining shapes at the start of a sketch gets the big picture down in your sketchbook quickly. You can then move to smaller shapes and details or you can decide to leave out detail and let the viewer complete the picture using their imagination.

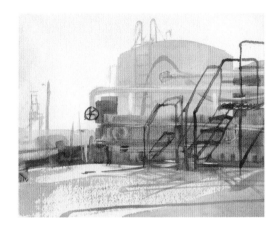

☞ Laurie Wigham suggests the great complexity of pipes, rails, and other mysterious equipment without overloading the scene with detail. She started her sketch with the big blue tank in the background, then layered on more shapes over it.

LAURIE WIGHAM
Potrero Power Station
10" x 9½" | 25.4 x 24.1 cm; watercolor

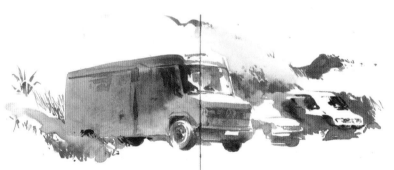

↑ João Catarino carves this scene out of positive and negative shapes, layering on smaller shapes for details.

JOÃO CATARINO
Surf Cars
9½" x 4¾" | 24 x 12 cm; watercolor

CELEBRATING TEXTURE AND PATTERN

Simplicity and restraint is one way to go. And on the other side of the scale, and equally beautiful, is texture, pattern, and abundance. Sometimes more is more.

↶ James Hobbs is drawn to architectural elements. His use of a thick pen and flat color puts the focus on the pattern-like quality of this view, with a selective use of color to move your eye around the composition.

JAMES HOBBS
Piccadilly, London

6" x 7¾" | 15 x 20 cm; pigment pens on paper and digital color

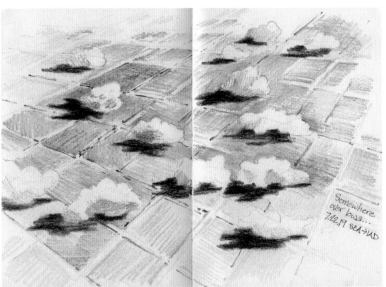

↷ Matthew Brehm's quilt-like sketch is a celebration of the seemingly endless grid of farmland with clouds casting beautiful shadows, all observed on a long flight.

MATTHEW BREHM
Somewhere Over Iowa

8" x 11½" | 20.3 x 29.2 cm; watercolor and colored pencil

🎧 William Cordero Hidalgo's sketch highlights the lush tropical vegetation in Costa Rica. You can see in the close-up that every inch of it has pattern and texture.

WILLIAM CORDERO HIDALGO

Golfito, Costa Rica

8¼" x 23½" | 21 x 59.7 cm; ink, graphite, watercolor

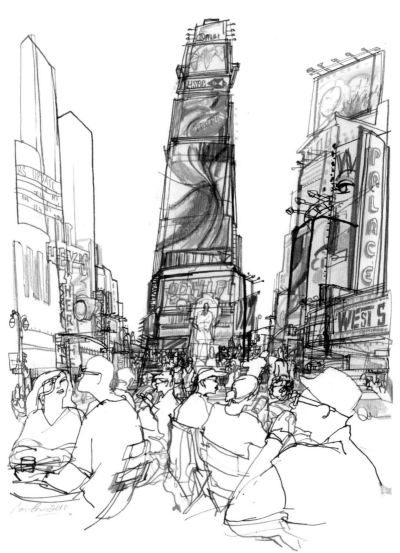

🎧 Is Times Square even
Times Square without
people?

VERONICA LAWLOR
Times Square Afternoon
9" x 12" | 22.9 x 30.5 cm;
pen and ink, colored pencil

KEY IV
WHAT TO SKETCH: PEOPLE

One of the most overlooked aspects of urban sketching is drawing people. We often draw urban environments designed for use by people, but not the people that occupy them.

People in urban sketches can be as simple as silhouetted shapes or they may be more articulated with faces and features and actions and gestures.

Drawing people is about drawing human stories that tell of places and of cultures, of what makes us unique and what we share in common.

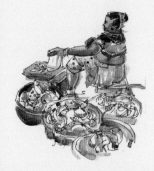

◖ Goan fisherwomen wear bright saris, flowers, and gold jewelry. To sketch them is not just about sketching colorful characters; it is also about capturing a profession, a culture, and a place.

SUHITA SHIRODKAR
Fish Market, Panjim, Goa
4" x 5" | 10.2 x 12.7 cm;
watercolor, pen and ink

SEEING SILHOUETTES

When sketching people from life, it helps to keep it simple because the people you are sketching might leave. When sketching in silhouettes, you can stop at a quick shape. If people stick around longer, you can keep going and add more detail. Or not.

Start Here
You Will Need

- A sketchbook
- A pencil or pen
- Watercolor or markers in shades of gray
- A white marker or white gouache

Visit your local café and take a seat somewhere toward the back, facing the front windows. If you're conscious of drawing in public, this is a relatively quiet place to sit. But more importantly, looking toward the windows transforms the people you're looking at into backlit shapes, devoid of most detail, which is exactly what you want.

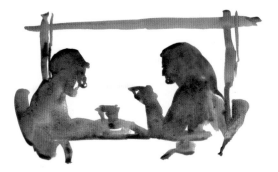

↻ **Step 1.** Look at a table with a person (or a couple of them) silhouetted against the window. Even seated people move a lot, and their gestures change. Try to pick a pose that the person will return to again and again.

Using your marker or paint, paint in the silhouette, thinking of it as a single shape with a carefully observed edges. Add shapes of objects you want in that single shape: cups, chairs, tables, windows. Here I used the grid created by the window frame and the table to frame and connect this scene into one big shape.

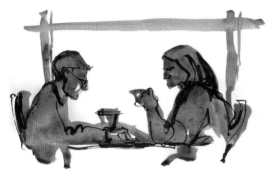

↻ **Step 2.** Using your pen or pencil, add some detail in line. Trust your first shape; don't restate everything in line. Leaving some of the original silhouette shape without a bounding line keeps your sketch from feeling too tight. Suggest features instead of actually drawing in every detail. Step back and take a look at your sketch: you captured people in a café in a quick sketch.

↻ **Step 3.** If you'd like to take this further, block in smaller, darker shapes keeping these darker shapes continuous instead of breaking them up into little bits.

With white paint or marker, add rim lights you see at the edges of your backlit silhouette. Add them sparingly, as it's easy to overdo it.

SUHITA SHIRODKAR
Conversation over Coffee
5" x 7" | 12.7 x 17.8 cm;
watercolor, pen and ink

➲ If you're not comfortable drawing in public yet, perhaps there's a book reader or TV watcher in your home?

SUHITA SHIRODKAR
Reading in a Quiet Corner
5" x 7" | 12.7 x 17.8 cm;
watercolor, pen and ink

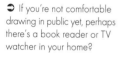

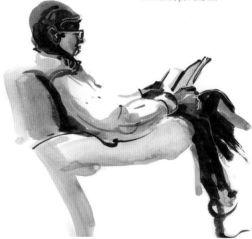

More Silhouettes

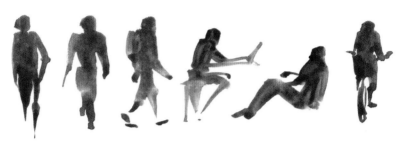

SUHITA SHIRODKAR
Silhouettes
6" x 2" | 15.2 x 5.1 cm;
water-soluble graphite

○ It takes very little to make a shape look like a human. We know the human body so well that some semblance of a head over a torso with limbs reads as a person.

With a little bit of observation added to the mark-making process, these simple shapes can convey a lot.

⤴ Shiho Nakaza's sketch tells a whole story in silhouette. This man is so engrossed in looking at his phone that he doesn't notice the birds watching him.

SHIHO NAKAZA
Curiosity
4" x 6" | 10.2 x 15.2 cm;
watercolor

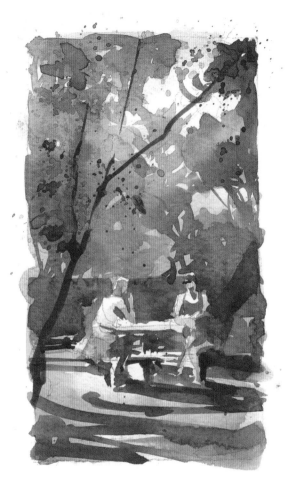

☛ Renato Palmuti builds the shapes of the landscape around his figures, carving out the silhouette of two people sitting in the sun.

RENATO PALMUTI
A Class in the Park
5⅛" x 8¼" | 13 x 21 cm; watercolor

♉ Your colors can bleed into each other in a silhouetted sketch. Blurry edges work because the silhouette does the heavy lifting here.

SUHITA SHIRODKAR
Summer Is Here
5" x 3" | 12.7 x 7.6 cm; watercolor

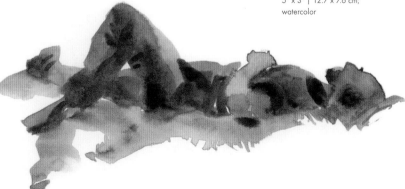

WORKING PAST YOUR FEARS

A fear of drawing people comes up repeatedly in talking to urban sketchers. And while it's true that the only way past your fears is to draw more, there are tactics that can help.

⊃ **Set self-imposed limits.** Limit your tools or the time you spend on every sketch. Inspired by the simplicity of Hokusai's Edo-era drawings, Richard Alomar takes his cues from them: he limits himself to simple forms and tools. In this series of New York City commuters, a pen and gray and rose-colored pencils are all he uses.

RICHARD ALOMAR
The Hokusai Series

Various sizes; colored pencil and ink

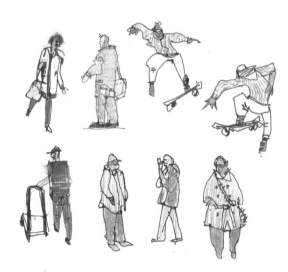

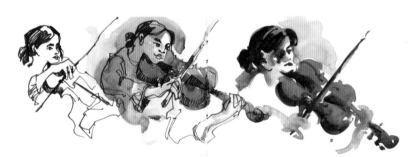

SUHITA SHIRODKAR
Violin Practice
16" x 6" | 41 x 15 cm;
watercolor, pen and ink

♠ Draw the same subject over and over. Regularly sketching my daughter practicing the violin has helped familiarize me with the shape of the instrument and the gestures involved.

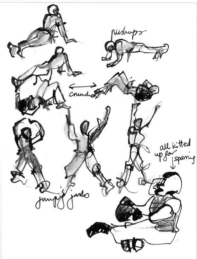

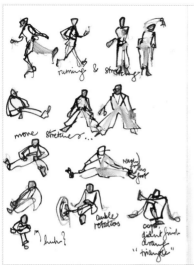

⊙ Don't obsess over faces. Too often, we obsess over faces in a sketch. In Nina Johansson's sketch of musicians playing together, there's just a hint of faces, no more.

NINA JOHANSSON
Mahler's Second Symphony at Konserthuset, Stockholm

7⅛" x 5½" | 18 x 14 cm; pen and ink

⊙ Draw in continuous line. To capture the fast moves in this tae kwon do class, continuous line (or almost continuous line) helped create flow. Working like this loosens your line, and working quickly means there is no space for judgment.

SUHITA SHIRODKAR
Tae Kwon Do Warm-Ups

16" x 10" | 40.6 x 25.4 cm; colored pencil and ink

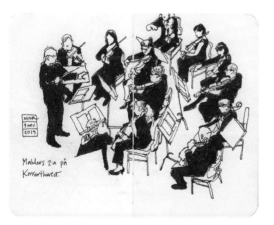

PLACES TO DRAW, FROM EASY TO CHALLENGING

Where do you draw people? Anywhere really—people are pretty ubiquitous in our world. But it is easier to draw them in certain situations, so let's look at some settings, ranging from easy to challenging.

Easy: Start at Home

Start in the comfort of your home. Draw the people in your home, doing what they do every day. Because that's what urban sketching is about—drawing your everyday world.

◔ Paul Heaston's older daughter passed out sitting up on the couch. And his little one fell asleep in her stroller. And Paul saw a rare opportunity to sketch the little people while they hold still.

PAUL HEASTON
Juni and Maggie
Each 3½" x 5½" | 8.9 x 13.9 cm; pen and ink

↻ Do you worry about people in your sketches not resembling people in real life? Remember, you're sketching people you know well, people who know you and love you, even if you draw them badly! But if you're still reluctant to draw their faces you can do what Nishant Jain does here when he sketches his mom cooking. Solves the problem, doesn't it?

NISHANT JAIN
Mom Cooks Food for Diwali

4" x 6" | 10.2 x 15.2 cm;
pen and ink

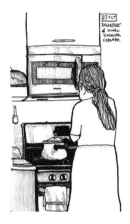

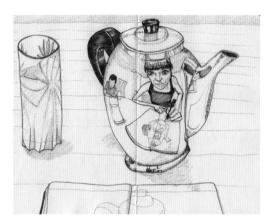

↺ No one to draw? Koosje Koene's clever take on a self-portrait captures so much of the environment around her. It's an urban sketch in a coffeepot.

KOOSJE KOENE
Reflections

8¼ " x 20" | 21 x 50.8 cm;
pen and ink

↻ When my son gets ahold of a book, I know he's going to stay put for a while. Time for a sketch.

SUHITA SHIRODKAR
Nishant Reading

5" x 5" | 12.7 x 12.7 cm;
watercolor, pen and ink

Step It Up: Sketch Close to Home

Ready to step a little bit outside of home? Try drawing at your local coffee shop or bar. Not only is it indoors, but you're also drawing people sitting (mostly) in one place.

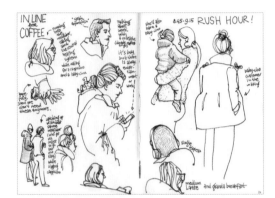

➲ Koosje Koene's coffee shop page combine notes with vignettes.

KOOSJE KOENE
Rush Hour at the Coffee Bar
8¼ " x 11½" | 21 x 29.2 cm;
pen and ink

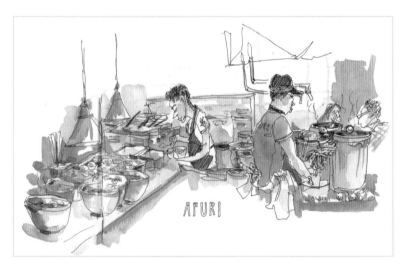

♠ Feeling more ambitious? Grab a ringside seat and watch the action, as Rita Sabler does here. If you're thinking there's no way you'll do this, consider this: the people at work are too busy to scrutinize your work. And, there's a lot of repetitive action, so you don't have to get a pose done in one instance.

RITA SABLER
Ramen Chefs at Afuri in Portland
7½" x 10" | 19 x 25.4 cm;
ink and watercolor

Taking It Further Afield: Drawing Out in the World

Draw where there is a steady stream of people to sketch. First, you're much less likely to be observed. And second, there's less pressure to draw superquickly. If the person you are drawing moves away, you can always finish the drawing from the next observed figure with a similar pose.

☞ On vacation, Shari Blaukopf finds subjects all around her at the beach. Choose an unobtrusive angle and sketch at your leisure.

SHARI BLAUKOPF
Red Line People
8¼" x 11½" | 21 x 27.9 cm; watercolor

☞ I was never out of people to sketch at Central Park.

SUHITA SHIRODKAR
Summer in Central Park
8½" x 11" | 21.6 x 27.9 cm; watercolor, pen and ink

☞ Anything is interesting when you draw it. Marina Grechanik captures action on a street corner.

MARINA GRECHANIK
Old Port in Amsterdam
11¼" x 7¾" | 28.5 x 20 cm; watercolor, colored pencils, acrylic markers

SIMPLE PROPORTIONS

With a little knowledge of basic proportions, your sketches can go from awkward to convincing. It's important to remember that proportion and ratio guides are generic. The beauty of people is that we are all variations on these shapes and ratios, and that is what makes us interesting individuals. Here are some tips that will help you get better proportions in your sketches.

1. An adult human is usually between seven and eight heads tall.

2. The hips (not the waist) are about halfway down the body.

3. When standing with arms hanging down, fingertips reach around mid-thigh.

4. Legs are longer than arms, and both bend at about midpoint. (At the knee and the elbow, respectively.)

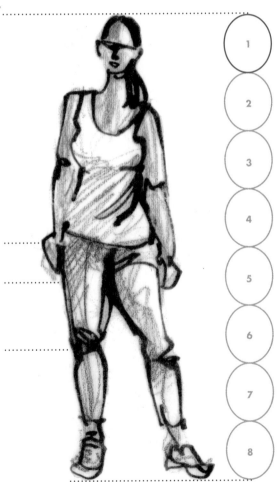

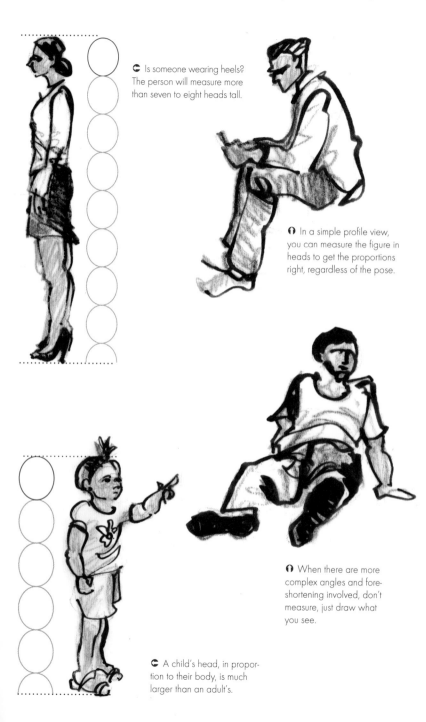

↩ Is someone wearing heels? The person will measure more than seven to eight heads tall.

↩ In a simple profile view, you can measure the figure in heads to get the proportions right, regardless of the pose.

↩ When there are more complex angles and fore-shortening involved, don't measure, just draw what you see.

↩ A child's head, in proportion to their body, is much larger than an adult's.

SHAPE AND SPACE

People occupy space in the real world. On our sketchbook page, that translates into a two-dimensional shape. Learning to see these bounding shapes helps understand postures and action.

↻ Compare these sketches. On the left, a standing person. On the right, a person walking. When you think of them as shape, the standing pose, with two feet on the ground, is a rectangle.

But one foot is going to appear pushed back in space when walking. When translated into a two-dimensional surface, that leg looks shorter, making the bounding box look like a triangle standing on its apex.

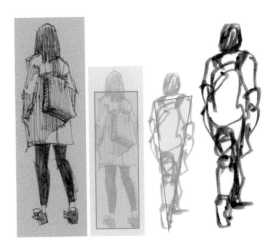

⋔ PAUL HEASTON
Pen on tinted paper

⋔ SUHITA SHIRODKAR
Pen and Ink

⋃ The shape and space we occupy is often dictated by how our bodies fit our surroundings. Think of the shape of the chair under this woman and then see how her form fits and echoes that shape.

KATE BARBER
Meditation on a Crochet Hook
iPad Pro, Apple Pencil, Procreate

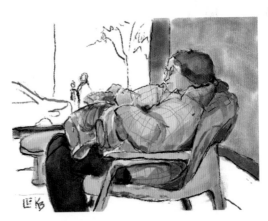

A shape you'll commonly see in a lot of postures is a wide-based triangle. Makes sense, because it's a stable shape and people are (usually) balanced and not falling over.

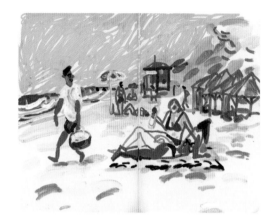

↩ In Marina Grechanik's sketch at the beach, you'll see lots of triangle-based poses: the man walking by, the women sunbathing, and more in the distant figures too.

MARINA GRECHANIK
"How Are You, Girls?"
11½" x 8" | 29 x 20.5 cm;
acrylic markers

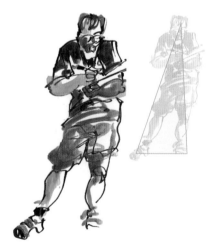

↪ My subject, Mark, has an easy, stable stance as he sketches.

SUHITA SHIRODKAR
Mark Sketching
4" x 8" | 10.2 x 20.3 cm; watercolor, pen and ink

↪ Not all shapes are simple, nameable shapes. Think of the space this person occupies. Plotting it on your page, either in pencil or just mentally, will help you with placing a person within it.

DON LOW
Untitled
6¼" x 7½" | 16 x 19 cm;
brush pen

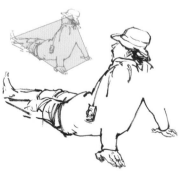

FACES AND HEADS

To draw individual characteristics and personality, it helps to understand a little bit about faces and features and the head and its structure. These are generalized proportions, a good way to understand structure but not a replacement for observation.

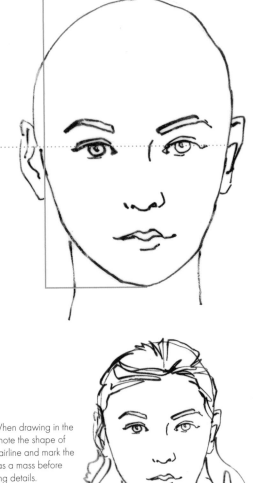

Looking straight on at an adult head:

1. The head is not a circle; it is an oval.

2. The eyes are halfway down the head (further down than we tend to draw them!) and about an eye length apart. Eyebrows lie above them.

3. The top of the ear lines up with the eyebrow.

4. Hint at the bottom of the nose instead of drawing it all in. The bottom of the nose and the bottom of the ears generally line up.

5. Leave some space for the upper lip and hint at the lips.

➲ When drawing in the hair, note the shape of the hairline and mark the hair as a mass before adding details.

The adult head, seen in profile:

1. The head goes back deeper than most people draw it. If you draw a bounding box around it, it forms a square.

2. The ear, with its top lined up with the eyebrow, is more than halfway back on the head.

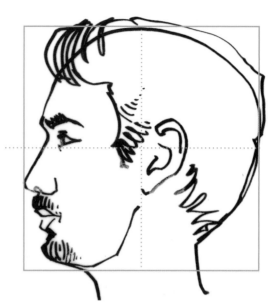

↺ Use generalized proportions as a start, but also notice how proportions vary from person to person. The beauty of a face and features lie in individuality. Celebrate it.

 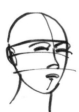 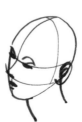

↺ While the head can look relatively flat when seen straight on, it's better to understand it as dimensional with lines of latitude and longitude. Visualizing it like this helps understand the head from any angle.

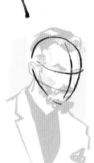

↻ Thinking of the head in dimension helps create this quick portrait with a just a few lines and shapes.

ROB SKETCHERMAN
Detail from People Watching

iPad Pro, Apple Pencil, Procreate

↪ Notice how the ears seem to "move up" in the head when a person looks down. You'll see it when you sketch someone looking down at their phone, computer, or book.

MARK ALAN ANDERSON
Detail from Learning, Visually. Gladstone, Missouri

Pen and ink

↪ I had front row seats at this performance. Note the strong shape of the underside of the jaw that you see from this angle.

SUHITA SHIRODKAR
Detail from Orchestra Performance

Watercolor, pen and ink

STYLE AND EXPRESSION

You can accentuate, exaggerate, and stylize your sketches to highlight a certain aspect of them.

☛ The exaggerated bent-over posture and hands of these kids captures their complete absorption and focus.

NELSON PACIENCIA
My Kids Playing with Legos

A5 (5.8" x 8.3" | 14.8 x 21 cm); ballpoint pen and water-soluble colored pencil

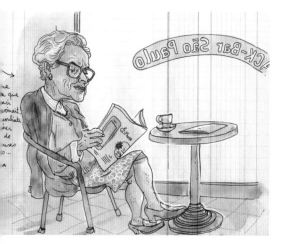

☛ Lapin's portraits often exaggerate the size of the head. His expressive style reflects his interest in individual faces and features.

LAPIN
Dias

8¼" x 6" | 21 x 15.5 cm; ink pens, watercolor, colored pencils, white Gelly Roll

☛ Rob Sketcherman borrows the style and proportions of fashion illustration to sketch people at the mall, paying as much attention to what he leaves out as he does to what he sketches.

ROB SKETCHERMAN
People Watching

8000 x 4000 pixels; iPad Pro, Apple Pencil, Procreate

GESTURE

Gesture is hard to define, but you will know it when you see it. Gesture has emotion, energy, and action. It is the essence of something, usually drawn quickly, often a first impression.

↩ Do you feel the anticipation of these players, ready to spring at the ball? That is gesture. To capture it Marina Grechanik works fast with the simplest of tools.

MARINA GRECHANIK
Ball Players at Sunset
11½" x 8" | 29 x 20.5 cm; ink

↪ To draw Nia dancing, Cathy Gatland watches for a long time, feeling the form and energy of the dancers before she sketches them quickly, trying to capture typical and descriptive poses.

CATHY GATLAND
Nia Dancing Hyah!
A4 (8¼" x 11½" | 21 x 29.7 cm);
pen and watercolor

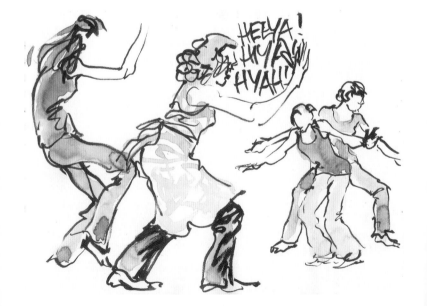

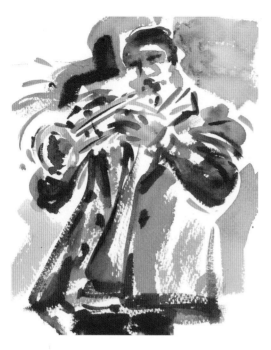

⟳ When you look at this sketch, do you imagine you hear the music? When Richard Sheppard sketches, his brushstrokes mimic the music, like he's playing along with the band. That's how he captures music in his sketch.

RICHARD SHEPPARD
Joel Behrman on Trumpet with the Anton Schwartz Quartet

8" x 10" | 20.3 x 25.4 cm; watercolor

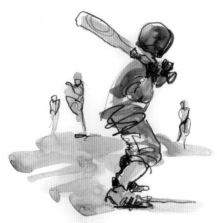

⟳ I love this moment in baseball when the batter and pitcher are like coiled springs, ready for action. Since it repeats over and over in a game, I capture the gesture of each person over multiple pitches.

SUHITA SHIRODKAR
Little League Baseball

6" x 6" | 15.2 x 15.2 cm; watercolor and water-soluble colored pencil

Drawing people who look alive and moving is a vastly fascinating subject to explore. If it interests you, you might like *The Urban Sketching Handbook: People and Motion* by Gabriel Campanario or *The Urban Sketching Handbook: Drawing Expressive People* by Roísín Curé, which cover it in depth.

DRAWING A CROWD

Drawing a crowd is, in many ways, easier than drawing individual people because it's a much more forgiving process. Not every person in your sketch has to work out perfectly; you just need to capture the energy and feel of a crowd.

Here are a few observations that can help those sketches hang together well.

1. It helps to be standing up when drawing a crowd. You see more of the crowd, and if the ground in front of you is flat, all heads line up at your eyeline (give or take a little bit for height differences), whether the person is closer to you or further in the distance. Of course, this doesn't apply to little kids.

2. The most detail and the strongest contrasts are in the foreground. Colors desaturate as you move into the distance. Details disappear too.

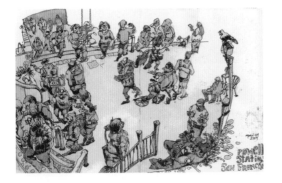

↻ When viewed from above, a crowd is scattered all over the page, filling it top to bottom. Heads don't line up at your eyeline anymore, but using overlap to create a crowded feeling still works.

OLIVER HOELLER
Powell Station, San Francisco
16" x 10" | 40.6 x 25.4 cm;
pen, brush pen, watercolor,
gouache, and acrylic markers

3. Overlap figures to create the feeling of a crowd.

4. Suggest the background, keeping perspective in mind.

5. Keep it real: use varying skin tones and note the colors of the clothing people are wearing.

↻ **SUHITA SHIRODKAR**
Farmers' Market, Princeton Plaza
12" x 9" | 30 x 23 cm; watercolor, pen, and ink

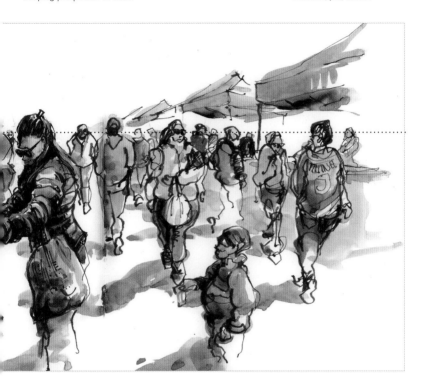

⊃ Even abstracted into shape and color, the energy of the crowd remains.

LAURIE WIGHAM
Women's March, 2020
10" x 7" | 25.4 x 17.8 cm; pen and watercolor

↻ An unusual angle turns an ordinary street scene into something special.

OLIVER HOELLER
*Victorian House,
San Francisco*

8" x 11" | 20.3 x 27.9 cm; pen, brush pen, watercolor, colored pencil, markers

KEY V
BRINGING IT ALL TOGETHER

We've looked at drawing objects, places, and people in the three preceding sections. In the best of urban sketching, the three come together seamlessly to record the world around us.

Bringing together myriad elements requires understanding their relationship to each other and using compositional tools for visual clarity.

In this section, we'll explore some of these concepts and look at how different sketchers make choices to tell their story.

➲ This sketch tells a poignant story of ghost bikes, somber memorials for bicyclists who have been killed by cars.

CATHY RAINGARDEN
Ghost Bike

8" x 11" | 20.3 x 27.9 cm;
watercolor and white gel pen

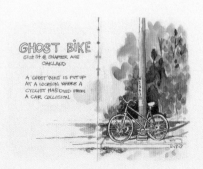

GHOST BIKE
51st St @ SHAFTER AVE
OAKLAND

A "GHOST BIKE" IS PUT UP
AT A LOCATION WHERE A
CYCLIST HAS DIED FROM
A CAR COLLISION.

RELATIVE SCALE

Pick a spot to sketch from: the only requirement is that there be a simple-shaped object in the foreground as we will use it to measure relative sizes in our scene.

Start Here
You Will Need

- A sketchbook
- A pencil
- Pen
- Watercolor

SUHITA SHIRODKAR
Two-Car Driveway
6" x 8" | 15.2 x 20.3 cm;
watercolor, pen and ink

↻ **Step 1.** Start by marking the simple shape and position of your foreground object on your page. Now compare the relative sizes and positions of other elements in your composition to it.

The first shape I marked is the roundish bush in the foreground. Its length is what I will use as a standard measure. The car, further in the distance, is about one measure long and half a measure high. The side of the house is about two measures high and the recycling bin in the distance, a quarter of a measure. Measuring relative scale across the foreground, middle ground, and background of a scene gives you a sense of how quickly things diminish in size from front to back.

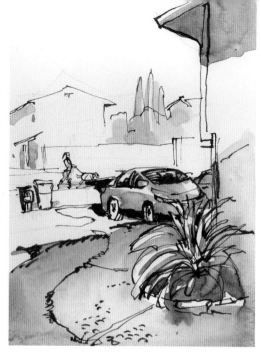

☞ **Step 2.** Now you can ink in your sketch. I work from foreground to background, using my thickest line in the foreground and thinner line in the distance. When the lady walking her dog passes by, I ink her in. When sketching on location, it helps to be flexible and willing to add something interesting in your scene on short notice.

People move quickly! The other thing that changes quickly is shadows. If I like the shadow shapes I see, I'll paint them in first.

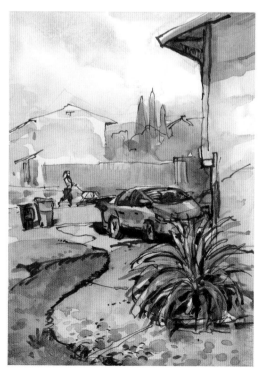

☞ **Step 3.** Lastly, paint your sketch.

Measuring in relative sizes helps create depth and distance in this sketch, but it's not the only technique I employ here.

• I also use thicker lines in the foreground and thinner lines in the background.

• There is more texture and detail in the foreground, less in the middle ground, and the least in the background.

• Colors are more vivid in the foreground, more muted in the background.

• The foreground and middle ground have a wide range of values; the background has only light values.

PEOPLE AND PLACES

To make people and place work together in a sketch, think about their scale and relationship to each other.

↩ Notice how Eleanor Doughty always maintains the scale of people in relation to the architecture. Notice the size of people juxtaposed against doorways and shop windows.

ELEANOR DOUGHTY
Broadway, New York City

12" x 8" | 30.5 x 20.3 cm; parallel pen and gel pen

↪ When you want to communicate the unfamiliar, offset it against what is known. These giant mojigangas in San Miguel de Allende are juxtaposed against normal sized people and buildings to highlight their scale.

RITA SABLER
Mojigangas of San Miguel de Allende

10" x 7" | 25.4 x 17.8 cm; watercolor and pen

COMPOSITION

To compose is to put together. You could be putting together the elements of a sketch or a series of little sketches on a spread.

Compositional techniques are a vast set of tools. Each tool will give you a unique result. What's important is asking yourself what you want your sketch to say, and then picking techniques that supports your intent.

Focal Point

Decide what the most important thing in your sketch is and make it the focal point. It's simplest to have just one focal point, but if you have more than one, decide which is the main one.

◖ There's no doubt what the focus of Fred Lynch's story is. The single painted door is the link to a story of his ancestors who lived there.

FRED LYNCH
Pawcatuck House
8" x 10" | 20.3 x 25.4 cm;
pen and ink

◖ Don Low frames one woman with squares of color behind her, making her the main focal point. The second woman's head, and the poster above with the black dot, create supporting focal points. If you have multiple focal points, odd numbers work better than even ones.

DON LOW
Conversation in Starbucks
6¼" x 9½" | 16 x 19 cm;
iPad Pro, Apple Pencil, Procreate

Rule of Thirds

One of the most common composition techniques is the rule of thirds. If you laid a grid of thirds over a sketch, the points at which the lines of thirds intersect hold a special attraction to our eyes. Knowing this, it makes sense to place what is most important in our sketches on these points.

↻ Anne Rose Oosterbaan places her most striking element, the church, right where the lines of thirds intersect. She also places the horizon on a line of third, giving her a visually pleasing split of sky and cityscape.

ANNE ROSE OOSTERBAAN
Haarlem Skyline
9¾" x 13¾" | 25 x 35 cm;
pen and ink, watercolor

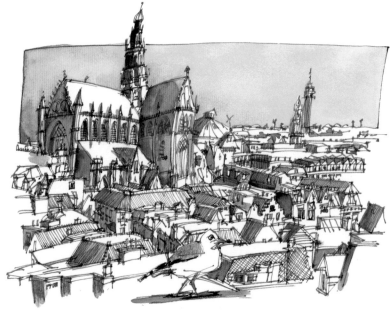

Visual Path

Creating a visual path through your sketch helps direct the viewer's eye around your work.

➾ Maru Godàs's sketch literally has a path that walks you into it.

MARU GODÀS

Winter Painting in Dr. Pla i Armengol Gardens

8½" x 13" | 21.9 x 33 cm; acrylic gouache and acrylic ink

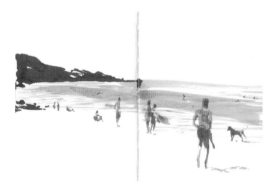

➾ In João Catarino's sketch, the visual path closely follows the line where the sea meets the sand. João helps your eye move along that path with the people (and a dog) that dot the beach.

JOÃO CATARINO

Ericeira Surfing Beach

11½" x 8¼" | 29 x 21 cm; watercolor

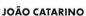

Rhythm and Repetition

Rhythm and repetition work hand in hand. They are best understood in terms of music. Like music, you need enough similarity for unity, but enough variation for interest.

⊃ In this sketch, the diagonal shadows add dynamism to the quieter rhythm of the vertical and horizontal lines.

FRED LYNCH
Viterbo Clothesline
8" x 10" | 20.3 x 25.4 cm;
pen and ink

↻ Sharp, angular motifs give Sanjeev Joshi's sketch quite a different mood from the sketch above. Sanjeev prepaints multiple sketchbook pages at home. When he sits down to sketch, he uses a page that matches the tone of the scene before him.

SANJEEV JOSHI
Dorabjee, Pune Camp
11" x 8" | 27.9 x 20.3 cm;
colored ink, pen and ink

Contrast

Contrast is about distinct differences. It brings variety and interest to compositions. Strong contrast will draw the eye in first, making it the focal point.

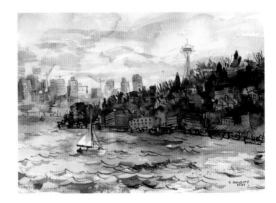

➲ Eleanor Doughty places a lone sailboat with its white sail set against the darker sea and landforms. The contrast makes it the focus on the sketch, the place where your eye lands first.

ELEANOR DOUGHTY
Wind on Lake Union, Seattle
15" x 11" | 38.1 x 27.9 cm;
watercolor

In most well-composed sketches, you will see that multiple compositional tools come together to create a strong sketch. Looking at works you admire and studying them for composition helps you see which tools are used to create those pieces.

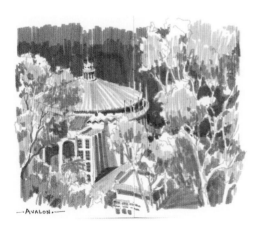

➲ Brenda Swenson composes her sketch so that the Catalina Casino roof lies on an intersection of the lines of thirds. The light shape of the roof contrasts with the dark of the sea beyond. Additionally the eucalyptus trees frame it, making it the center of focus in this sketch.

BRENDA SWENSON
Avalon
8" x 16" | 20.3 x 40.6 cm;
Pitt pens in three shades of gray

CHALLENGES

Do you feel stuck in the doldrums with your art practice once in a while? Or perhaps you spend too much time pondering what to draw. Try using one of these prompts to get you back to sketching while exploring new tools and techniques.

SET YOURSELF A PERSONAL CHALLENGE

Pick a focused challenge for yourself. It can be something short that you do for a day, or a longer challenge that gives you a goal to work toward and takes away the paralysis of "What shall I sketch now?"

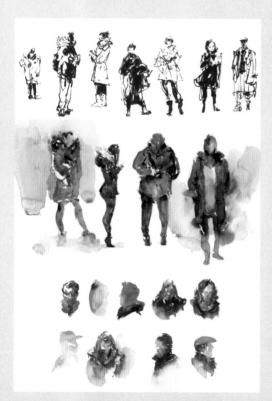

◖ Once a year, Marc Taro Holmes sets himself the challenge of drawing 100 people in one day. Speed and repetition and something about that large number takes away the expectation of making perfect sketches.

MARC TARO HOLMES
One Day, 100 People

Various sizes; watercolor, brush pen

DRAW THE SAME THING OVER AND OVER

You'll be surprised by what you learn when you draw the same thing over and over.

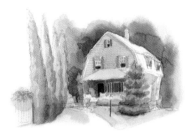

◑ Here are four takes from Fred Lynch, all sketches of his home, all done in different styles. Pick a familiar subject. How many different ways can you sketch it?

FRED LYNCH
Eaton Court House
8" x 10" | 20.3 x 25.4 cm; pen and ink

◑ Judith Kunzlé's sketches are all from the same vantage point, sketched at different times in the year.

JUDITH KUNZLÉ
Shell Ridge Trail
Various sizes; watercolor, marker, pen and ink

TRY A NEW TOOL OR MEDIUM

Try something new. Learning happens when you stretch outside your comfort zone.

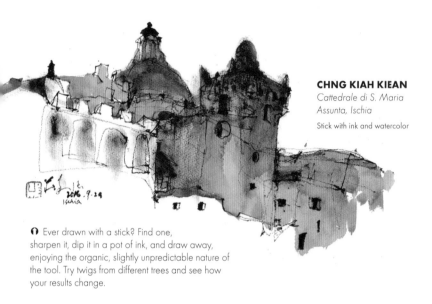

CHNG KIAH KIEAN
Cattedrale di S. Maria Assunta, Ischia

Stick with ink and watercolor

🎧 Ever drawn with a stick? Find one, sharpen it, dip it in a pot of ink, and draw away, enjoying the organic, slightly unpredictable nature of the tool. Try twigs from different trees and see how your results change.

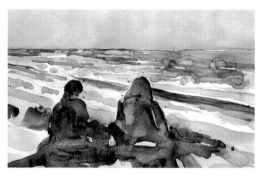

🔄 Try a new surface to sketch on. Andy Forrest plays with Yupo paper which gives his watercolors a completely new look.

ANDY FORREST
Sketchers at Ocean Beach, San Francisco

11" x 15" | 28 x 38 cm; watercolor on Yupo paper

◑ Try a new medium. This vibrantly colored sketch uses acrylic markers.

SWASKY
Detention Room

7¾" x 13" | 20 x 33 cm;
acrylic markers

◑ Mix together unusual media for a surprising result. A combination of acrylic markers and crayons creates this painterly effect.

JENNY ADAM
Chez Jacky, Ouessant, France

11" x 8" | 27.9 x 20.3 cm;
wax crayons and acrylic markers

SKETCH AT A TIME OR PLACE YOU NEVER DO

◖ Are most of your sketches done in the daytime? Try a nighttime sketch. If it's too hard to sketch outside, do what Jenny Adam did here: she drew this nighttime street sketch looking out from her hotel room.

JENNY ADAM
Bui Vien Street, Saigon, Vietnam

8" x 6" | 20.3 x cm;
pen and watercolor

↻ Try going someplace you avoid sketching—a really busy market, perhaps? If you find busy places overwhelming, you can try what Santi Sallés does here: focus on what's being sold, adding only enough background to create a sense of place.

SANTI SALLÉS
Moroccan Weekly Market

11½" x 8¼" | 29 x 21 cm;
watercolor, colored pencils,
oil-based graphite pencil

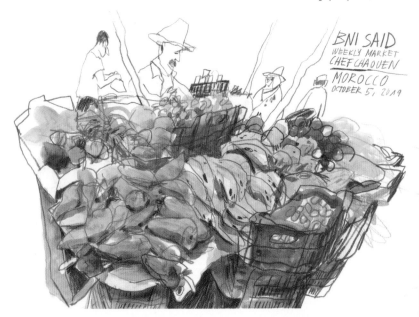

TAKE A LINE FOR A WALK

Pick a simple tool and start anywhere in the scene before you, "walking" your line across the contours and space of the scene.

↻ You can feel the energy of Simone Ridyard's line, traversing up and down and back and forth in space, recording this scene.

SIMONE RIDYARD
Arsenale, Venice
A5 (5.8" x 8.3" | 14.8 x 21 cm);
fineliner pen

♁ Ketta Linhares walks her line across this sweeping view, pausing to add texture and detail or to leave out a contour and let the viewer complete the picture.

KETTA LINHARES
Campo das Cebola, Lisbon
16" x 6.3" | 41 x 16 cm;
fineliner pen

SKETCH IN LAYERS

Overlapping and juxtaposing can tell a story that simply capturing a scene, as is, could not. Think of instances where layering can help communicate your point.

↻ Mário Linhares juxtaposes a line drawing of his son against a watercolor of the beach. He plays with scale and mixes media to capture this memory in a way that balances the portrait of a little child with the vastness of the beach.

MÁRIO LINHARES
Matias' beach world
16" x 6" | 41 x 15 cm;
watercolor and oil-based pencil

↻ Swasky illustrates the steps in glass blowing by first drawing the environment of the glass factory and then layering on the craftsmen.

SWASKY
At the Royal Glass Factory in la Granja, Spain
15" x 7.5" | 38 x 19 cm;
ink and colored pencil

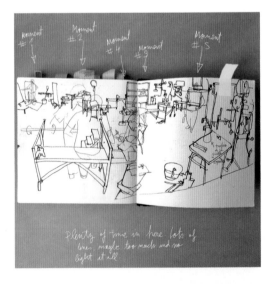

RECORD A STORY

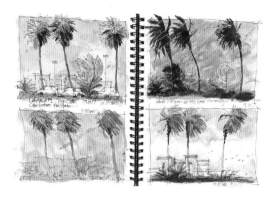

⭢ James Richards drew this series of sketches in a 24 hour period, recording the progress of Hurricane Irma over central Florida.

JAMES RICHARDS
*Four Stages of
Hurricane Irma*

12" x 18" | 30.5 x 45.7 cm;
watercolor and pen

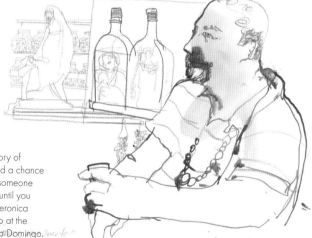

⭢ Record the story of someone you had a chance interaction with, someone you didn't know until you sketched them. Veronica Lawlor met Papito at the *mercado* in Santo Domingo. Between the tiny bit of Spanish she spoke and his English, he told her stories, and offered her a coffee. Recorded in this sketch is her memory of a place, a person, and a cup of coffee.

VERONICA LAWLOR
Papito

12" x 9" | 30.5 x 22.9 cm;
colored ink and pencil

Telling stories and documenting events through sketching gets to the very heart of what urban sketching is all about. If it interests you, read *The Urban Sketching Handbook: Reportage and Documentary Drawing* by Veronica Lawlor, which explores the many facets of reportage.

CONTRIBUTORS

Jenny Adam
jennyadam.com

Shilpa Agashe
Instagram:
@agasheshilpa

Elizabeth Alley
elizabethalley.com/
sketchwork

Carlos Almeida
Instagram: @sketchviews

Richard Alomar
Instagram:
@richard_alomar

Mark Alan Anderson
Instagram: @azorch

Kate Barber
Instagram: @kate5667

Shari Blaukopf
shariblaukopf.com

Jane Blundell
janeblundellart.com/
plein-air-sketches.html

Stephanie Bower
Instagram:
@stephanieabower

Matthew Brehm
Instagram: @mtbrehm

Richard Briggs
Instagram:
@richardbriggs_artist

Gabriel Campanario
estudiocampanario.com

Chris Carter
chriscarterart.com

Genine Carvalheira
Instagram:
@geninecarvalheira

João Catarino
Instagram:
@joaocatarino65

Maria Coryell-Martin
expeditionaryart.com

Hugo Barros Costa
Instagram: @yolahugo

Eleanor Doughty
edoughty.com

Ian Fennelly
Instagram: @ianfennelly

Andy Forrest
Instagram:
@seismicwatercolors

Cathy Gatland
Instagram: @cathartland

Maru Godàs
marugodas.com

Marina Grechanik
marinagrechanik.
blogspot.com

Howie Green
Instagram: @howiegreen

James Gurney
Instagram:
@jamesgurneyart

Paul Heaston
Instagram: @paulheaston

Virginia Hein
Instagram: @virginiahein

William Cordero Hidalgo
Instagram:
@williamcorderoh

James Hobbs
Instagram:
@jameshobbsart

Oliver Hoeller
oliverhoeller.com

Marc Taro Holmes
citizensketcher.com

Nishant Jain
sneakyartist.com

Nina Johansson
Instagram:
@nina_sketching

Sanjeev Joshi
Instagram: @sanjmita

Uma Kelkar
umakelkar.com

Nina Khashchina
blog.apple-pine.com

Ch'ng Kiah Kiean
Instagram: @kiahkiean

Koosje Koene
Instagram: @koosjekoene

Gay Kraeger
watercolorjournaling.com

Judith Kunzlé
judithkunzleart.com

Lapin
Instagram:
@lapinbarcelona

Veronica Lawlor
veronicalawlor.com

Ketta Linhares
duplapagina.blogspot.com

Mário Linhares
hakunamatatayeto.
blogspot.com

Don Low
Instagram: @donlowart

Fred Lynch
FredLynch.com

Heather Ihn Martin
heatherihnart.com

Cathy McAuliffe
Instagram: @gusmcduffie

Marcia Milner-Brage
flickr.com/photos/
marciamilner-brage

Ed Mostly
mostlydrawing.com

Shiho Nakaza
Instagram: @shihonakaza

Anne Rose Oosterbaan
anneroseoosterbaan.nl

Nelson Paciencia
Instagram:
@nelson_paciencia

Renato Palmuti
renatopalmuti.com

Cathy Raingarden
Instagram:
@cathyraingarden

Andy Reddout
Instagram: @areddout

Steven Reddy
stevenreddy.com

James Richards
Instagram: @jrsketchbook

Simone Ridyard
Instagram:
@simoneridyard

Rita Sabler
portlandsketcher.com

Santi Sallés
santisalles.com

Richard Sheppard
theartistontheroad.com

Suhita Shirodkar
suhitasketch.com

Rob Sketcherman
sketcherman.com

Alex Snellgrove
Instagram:
@alexsnellgrove

Liz Steel
lizsteel.com

Karen Jiyun Sung
Instagram:
@caffeinated.karen

Swasky
Instagram: @swasky

Brenda Swenson
swensonsart.net

Tracey Thompson
Instagram:
@traceythompson

Paul Wang
Instagram: @paulwang_sg

Laurie Wigham
lauriewigham.com

Gail Wong
Instagram: @glwarc_seattle

Teoh Yi Chi
Instagram: @parkablogs

ACKNOWLEDGMENTS

Thank you to all the urban sketchers who so generously allowed their work and words to be reproduced in this book. Your excellence in what you do, passion for urban sketching, and support for this project made it possible. Thank you, Gabi Campanario, for your vision and work in creating an amazing community. A big shout-out to the hundreds of urban sketchers around the world who answered questionnaires and shared their thoughts, challenges, and advice for beginning sketchers: your input helped shape the content and direction of this book.

Many thanks to my editor, Joy Aquilino, art director, David Martinell, and the team at Quarto Books for bringing this book to life. And as always, thanks to my family for supporting my obsession with sketching and my projects: from my parents who always kept my crayon box and sketchbook supplies replenished when I was a kid, to my husband Hari, kids Kavya and Nishant, sister Suhag, and nieces Mohini and Mallika, who get to hear of and support the nitty-gritty of every project I work on, including this one

ABOUT THE AUTHOR

Suhita Shirodkar is an urban sketcher, art director, illustrator, journalist, and teacher. She is the recipient of a Knight Foundation grant for her reportage covering vintage signs in San Jose. An international correspondent with the nonprofit Urban Sketchers, Suhita has taught at the Art Institute in Sunnyvale, California, and has taught urban sketching workshops in exciting locales around the world. She has been featured in *The Mercury News* and on KQED, and she also runs a popular Etsy store where she sells her artwork. Born in India, she currently lives in San Jose, California.

Photo courtesy of
Hari Shankar